Miami's
Criminal Past

Miami's Criminal Past UNCOVERED

Sergio Bustos & Luisa Yanez

THE
History
PRESS

Published by The History Press
Charleston, SC 29403
www.historypress.net

Cover image: Illustration by Dan Garrow.

First published 2007

Manufactured in the United States

ISBN 978.1.59629.388.5

Library of Congress Cataloging-in-Publication Data

Bustos, Sergio.
Miami's criminal past uncovered / by Sergio Bustos and Luisa Yanez.
p. cm.
ISBN 978-1-59629-388-5 (alk. paper)
1. Crime--Florida--Miami--History. 2. Murder--Florida--Miami. 3. Murder victims--
Florida--Biography. I. Yanez, Luisa. II. Title.
HV6795.M48B87 2007
364.152'30922759391--dc22
2007036328

To the women in my life. My wife, Lilliam. My daughters, Monica and Michelle. My mother, Rosa, and my sister, Patricia.

—Sergio Bustos

To my family: *mi mamá*, Gloria; my siblings, Romina, Evy and Romulo; my nephews, Christian, Ariel and Richie; and aunt, Ana. And to those who make a difference: D.B., S.L. and K.R.

—Luisa Yanez

Contents

Foreword

When I first thought about putting together a regular feature about Miami's past, I wanted *Miami Herald* readers to be able to revisit a part of South Florida history through words, photos and video.

The idea in the fall of 2006 was to retell those moments in the past by updating readers on what had happened to some of Miami's most infamous and renowned characters.

My choice to do the work: Luisa Yanez, an experienced and talented reporter who grew up in Miami and has worked for the region's three major newspapers, and Sergio Bustos, her equally talented editor whose newspaper reporting experience was honed at the *Philadelphia Inquirer*, one of the country's best newspapers.

"Flashback" has since become one of the newspaper's most popular features. Together, Luisa and Sergio have provided our readers with a gripping collection of stories that delve deep into the fabric of Miami's rich history. I hope you enjoy them as much as we have in Miami.

Manny Garcia
Metro Editor, *Miami Herald*

Acknowledgements

The authors want to express their gratitude to the many people involved in helping turn this project from an initial proposal into a final publication.

We are especially grateful to *Miami Herald* Executive Editor Anders Gyllenhaal and Metro Editor Manny Garcia for giving us permission to pursue the book with The History Press.

We'd also like to thank former History Press Editor Dan Gidick for offering two first-time book authors the chance to submit a proposal. It was Dan who called the authors to suggest they submit a proposal for a book that was largely based on a regular feature the *Miami Herald* had been writing called "Flashback."

A special thanks goes to our current History Press editor, Melissa Schwefel, who has guided us novice book authors through a very unique process. We also must thank History Press copyeditor Lesleigh Patton, who carefully went over our original manuscript and offered excellent suggestions to improve it.

We cannot go without mentioning the fine assistance of those working in the *Miami Herald*'s library and the many *Miami Herald* photographers who captured on film what we put into print for this book. It was through these many photos that the authors were able to truly bring back to life Miami's past.

A very special thanks goes to Dan Garrow, a truly gifted graphic artist and illustrator with the *Wilmington (DE) News Journal*, and a very dear friend. Dan and Sergio have known each other since they began their journalism careers in the 1980s. They both worked together at the *News Journal*. Dan provided the authors with a compelling and gripping photo illustration for the book cover and provided maps at a moment's notice to illustrate each of the book's six chapters.

ACKNOWLEDGEMENTS

We also would like to thank Stephanie Loudis, an English teacher at Miami Palmetto Senior High who proofread our pages and saved us from any grammatical embarrassment. And my dear friend Tina, the best editor in town.

We would also like to thank all the people who allowed us to interview them and gave of their time to help us bring a piece of the past to life. In the Judith Ann Roberts chapter, we thank former Miami Police Detectives Irving Whitman and Warren G. Holmes, who worked the case. In the Jim Morrison chapter, thanks to the singer's former manager William Siddons, photographer David LeVine, Miami attorneys Robert Josefsberg and Donald Bierman and former Miami-Dade court clerk Gordon Winslow. In the Joseph Caleb chapter, we would like to thank his son, Stanley Caleb; Al Huston, current president of the Local 1652; and T. Williard Fair, head of the Urban League of Greater Miami. In the Carl Brown chapter, Michael Kram was invaluable. In the Christopher Wilder chapter, we would like to thank Haydee Gonzalez, mother of Wilder's first victim, Rosario Gonzalez, who to this day tries to keep the memory of her daughter alive. In the Versace/Cunanan chapter, we would like to thank the late former Miami Beach Detective Paul Scrimshaw, one classy guy, and one of his partners, Detective Gary Schiaffo, who gave unselfishly of his time for our story. Also helpful were former Miami Beach Mayor Seymour Gelber and city manager José Garcia-Pedrosa. And especially, former pawnshop worker Vivian Oliva, who revealed that she had sent Miami Beach Police the pawnshop paperwork—days before the Versace murder—with leads on where to find Cunanan.

Finally, the authors wish to thank our families and friends for providing inspiration and patience in helping us see this book through to the end. Sergio would especially like to thank his wife, Lilliam, and children, Monica and Michelle, for their encouragement.

Luisa would like to thank her mother, Gloria, from whom she inherited a love for a good, juicy tale. And also my many close friends who have patiently listened to me tell these stories to them over and over again. They are great sounding boards and they often helped me tell a better tale.

The Unsolved Murder of Six-year-old Judith Ann Roberts

Judith Ann Roberts was just a month shy of celebrating her seventh birthday as she spent the day frolicking at the popular Venetian Pool in Coral Gables with her three-year-old sister Betty. It was July 6, 1954, and the two girls were in the company of their grandparents and mother on another steamy, hot summer afternoon in South Florida. The young girls' father, James Roberts, had brought the kids and his wife, Shirley, to Miami on a vacation to visit his in-laws, Harry and Dora Rosenberg. He wanted to bring some joy to his children, especially the sickly Judith Ann, who had only recently undergone several painful operations to remove a tumor from her throat. She now seemed to be on the mend and in the best of health.

Roberts, too, had his own reasons for making the trip. He had been under much stress as an attorney for the United Auto Workers in Baltimore, Maryland. Adding to the tension in his life was his unsuccessful run weeks earlier for a seat in the Maryland state legislature in Annapolis. He ran as a candidate who supported labor unions in a state with strong union ties but couldn't muster a victory.

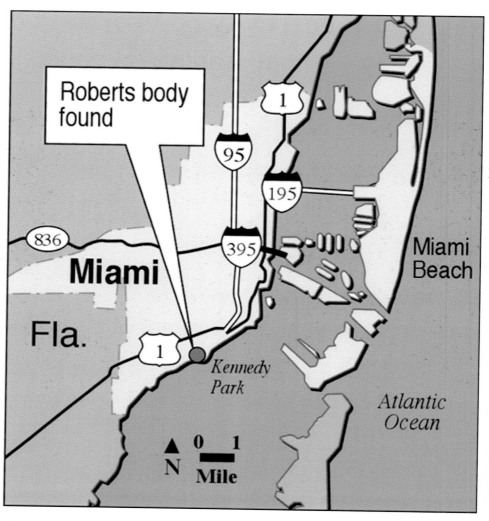

Roberts body
found

Miami
Beach

Miami

Fla.

Kennedy
Park

Atlantic
Ocean

0 1
N Mile

Courtesy of Dan Garrow.

The Unsolved Murder of Six-year-old Judith Ann Roberts

The political campaign, however, had taken a physical and financial toll on Roberts, a tall, beefy forty-three-year-old. All of those problems were seemingly forgotten in South Florida, where the slow pace of life was precisely what Roberts and his family had sought when they drove down from Maryland. The Roberts family had planned to spend two weeks in the Sunshine State. But it would turn out to be no vacation at all. The very next morning, the Roberts family would embark on a horrific journey that would forever alter the course of their lives. Miami, too, would undergo a metamorphosis of its own, losing its innocence as a small, sleepy, Southern town. Indeed, over the next several weeks and months, the Maryland family and the city of Miami would get the attention of the world for an event it wished had never happened.

The story of what unfolded in Miami that summer begins at the Rosenbergs' modest duplex home on Southwest Thirteenth Avenue. Back in the early 1950s, the neighborhood was home to mostly older, middle-class Jewish residents, many of whom had moved from the Northeast to escape the cold weather. It would later become the home of hundreds of thousands of Cuban exiles fleeing the dictatorship of Fidel Castro. The neighborhood sits near what is now known as Calle Ocho—Little Havana's main thoroughfare and the site of the nation's largest Hispanic street festival.

The Rosenbergs had purchased the two-bedroom duplex at 1234 SW Thirteenth Avenue after Harry Rosenberg's retirement from New York's garment district. The neighborhood is situated near downtown Miami. In the 1950s, it was quiet and dotted with typical Art Deco–style Florida homes, adorned with ornate wrought-iron screen doors that featured local iconic symbols like a palm tree, a flamingo or a jumping dolphin. The quiet avenue where the Rosenbergs lived was unusual for the area because it had a grassy median that ran along its entire stretch.

Today, the median is known as monument row and is home to numerous memorials of Latin heroes. Anchored on the Calle Ocho end is the Bay of Pigs Memorial, which commemorates the failed CIA-backed attack on Cuba in April 1961. To this day the spot remains a gathering place for anti-Fidel Castro exiles.

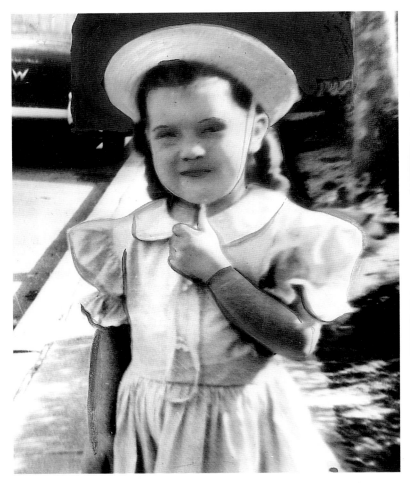

A photo of Judith Ann Roberts in her Sunday best. *Courtesy of the* Miami Herald.

The Unsolved Murder of Six-year-old Judith Ann Roberts

After spending the day at the public pool—popular at a time when few people had one in their backyard—the Roberts family came home that hot afternoon to bathe the girls and prepare them for dinner. It was a Tuesday and the girls plopped themselves in front of their grandparents' black-and-white television set to watch an episode of *Danger*, a popular half-hour anthology suspense series on the CBS television network. That night's episode was called "The Gunman," and starred a young actor named Ben Gazzara.

When the television show ended at 9:30 p.m., Judith Ann and Betty were put to bed by their grandparents. Judith Ann slept on the living room couch by the front door, under a front window. Her sister was in another makeshift bed on the back porch.

By 11:00 p.m., all the adults who were at home were in bed in the two bedrooms. There was one person not at home: the children's father, James Roberts. The doors were left unlocked for Roberts, who had been out most of the day with a female client, Dorothy Lawrence, a young woman who had driven down with the family from Baltimore. She was staying at his sister-in-law's house. Lawrence was an attractive twenty-five-year-old woman who worked as a waitress and was in the midst of a divorce. She was friends with Shirley Roberts and had hired James to handle her divorce, which was being settled in Miami.

With everyone fast asleep, the sound of a speeding car broke the silence of a quiet Miami night. The time was about 12:30 a.m. and the noise awakened Dora Rosenberg. The girls' grandmother later told police she had remained in bed until 1:00 a.m. That's about the time she got up and walked into the living room to check on the girls. She said her husband had been asleep next to her the entire evening. When she walked into the living room, Dora Rosenberg discovered a frightening sight: the front door was wide open and little Judith Ann was gone from her bed.

Frantically, she raced around the house, waking her daughter Shirley. The two women went outside and circled the house in a desperate search for Judith Ann. They didn't find her. Dora Rosenberg then ran back into the house and woke up her husband.

"Judy is missing!" she cried out to him. "Get the car and help us look for her."

Sleepy and startled, Harry Rosenberg ran out of the house. He was still wearing his pajamas. He, too, looked outside for the girl, and then dashed back inside to his bedroom to put on his trousers. It was there that he noticed something strange. His trousers were not on the bedpost, a place he religiously hung them every night before going to sleep.

He would later tell police that he found them on the living room floor, near the front door. He also said that he found that the back pockets, where he kept his car keys and a handkerchief, had been turned inside out. The information would later pique the interest of detectives. For now, it was just something strange to Harry Rosenberg.

Outside the home, the family realized the Rosenbergs' car was missing. It was a green 1952 Oldsmobile with a gray top. It had been parked on the curb in front of the house since the afternoon. Fearing the worst, Shirley Roberts picked up the telephone and dialed Miami Police.

That night, Miami homicide Detective Irving Whitman was working the graveyard shift at police headquarters. A transplant from New York, the thirty-two-year-old Whitman had never worked such a case. What the lanky detective didn't know then was that the call from the Rosenberg's home was about to turn his career upside down. For the moment, all Whitman knew was that a little girl on vacation from Maryland was missing in Miami, and he was charged with trying to find her.

Whitman quickly headed to the Rosenberg home and questioned the adults there. When he learned that Judith Ann's father was a union leader and politician, Whitman immediately called the FBI. His theory was that she might have been kidnapped for some kind of ransom. Agents and police swarmed the area. They searched the neighborhood and then spread out across the city, issuing a call to all police cars on patrol to look for a little girl who might still be wearing a white and red polka dot nightgown.

James Roberts finally arrived home at 2:30 a.m. and was told of his daughter's disappearance.

The Unsolved Murder of Six-year-old Judith Ann Roberts

At daybreak, investigators made a troubling discovery: a Miami patrol officer reported finding the Rosenbergs' car off Kirk Street in Coconut Grove, between South Bayshore Drive and Biscayne Bay. Today, the stretch of road marks the north end of David Kennedy Park, a popular spot for joggers. The park runs along South Bayshore Drive, a busy roadway buffeted by mansions on what is probably the only hilly section of Miami.

Whitman, along with a slew of police officers and firefighters, rushed to the spot. They found the Rosenbergs' car mired down in the sand beside the bay-front street. Track marks revealed the driver's frantic but futile effort to get the car out. But there was no sign of Judith Ann. The police reasoned that she could be in the nearby bay or may have been left to wander in the mangroves.

The news only got worse. At 6:15 a.m., Whitman remembers, a Miami fireman moved aside a clump of bushes a block south of the car and saw something. He yelled for Whitman to come over. Under the brush, they found the body of Judith Ann. She was still in her white and red polka dot nightgown. Her head had been savagely beaten. Her hands were tied behind her back with a thin rope and a washrag. She had been struck in the mouth, a blow so severe the Dade County coroner said it had jarred her teeth loose. Her thighs and genitals showed bruises caused apparently by a tree branch. A handkerchief, the same one taken from Harry Rosenberg's back pocket, along with his car keys, was tied as a gag to cover her mouth. A dish towel was knotted like a blindfold across her eyes. Her body was caked with a mix of blood and mud. The detective could tell that she had fought before being garroted and thrown into the tangle of underbrush. There had been much bleeding from her nose, mouth and groin. Her left eye was swollen and blackened.

"When I saw her poor little body like that, gagged and beaten, I couldn't help it. I broke down and cried," Whitman said.

"I just hope she was unconscious through this," said coroner Dr. Ben Sheppard. He put her time of death at between 1:30 a.m. and 3:30 a.m. As the lead investigator, Whitman quickly assessed the crime. He was skeptical that the killer had actually

used a tree branch to rape Judith Ann. It just didn't seem right, Whitman thought.

Police found little evidence to collect. For the moment, Whitman and just a few law enforcement agents knew the horror of the girl's death. It wouldn't remain that way for long. The rest of the world would soon learn details of a little girl's grisly death.

News of the horrific murder rocked not only 1950s Miami. Headlines, from Asia to Europe, trumpeted news of a sex maniac on the prowl in sunny Miami. The city was under siege on the eve of the winter tourist season. "It was bizarre. It became a total circus...I got calls from around the world," Whitman recalled. "Everybody had a theory."

The *Miami Herald* and the *Miami News*, the main local newspapers, called it "Miami's most shocking crime in years." They issued warnings to readers: "Lock Homes Before Retiring For the Night," "Warn Children About Molesters."

Even children remember the fear that gripped the city. Bonnie P. Bishop Byrd Gardner, who was then twelve years old, said she couldn't sleep. "I would stay awake most nights waiting to hear a neighbor's rooster crow so that I would know daylight was near. I have thought about what happened to Judith Ann many times over the past fifty years," said Gardner, who now lives in Georgia.

The Miami Police Department was overwhelmed with tips from a hysterical public. The media attention was unprecedented. Politicians, state law enforcement officials and even then acting Governor Charley Johns promised unlimited resources and a quick arrest. Whitman's team of detectives and Dade County State Attorney George Brautigan, who was up for reelection the same year, were taking this one personally.

More gruesome details were to come. Despite the killer's efforts to make it seem like a sex crime, the coroner's report revealed that Judith Ann had not been raped, affirming Whitman's suspicions. "You would think the tree branch had been used to sexually assault her, but that was a ruse," recalls Whitman. "The killer wanted to make it look like a sexual crime, but it wasn't."

Still, in the days and weeks following Judith Ann's murder, nearly two hundred men, known sex offenders, were rounded up and interrogated. Since the murder was labeled the work of a sexual deviant, many homosexual men were added to the list of those rounded up. Detectives turned their attention on the idea that a stranger, a burglar or even a peeping Tom had snatched the girl. Fueling speculation of a sexual deviant grabbing Judith Ann was a sympathetic spokeswoman: Shirley Roberts, the girl's mother. In her effort to help police solve her daughter's slaying, she tried to recall all the events of that night. She remembered that Judith Ann had danced around naked in the living room in the minutes after she had been given a shower.

"What I'm trying to bring out," she wrote to police in a letter, "is that anyone standing, peeking in the side window of my parent's room, would have clearly been able to see her. Maybe that would explain why he walked by Betty on the back porch, and my mother's silverware in the dining room. In his sick mind, he had been excited by Judy."

Two months passed and police had not made an arrest. Not for lack of trying. Investigators had chased several promising leads—all led to dead ends. The media spotlight didn't fade. Among the many potential suspects was one the media dubbed "the man in white." At least a dozen people called police to say they had seen a mysterious man dressed all in white walking near the area where the little girl had been murdered. After several stories describing the alleged killer, the man finally came forward. He turned out to be an innocent nighttime hospital orderly at nearby Mercy Hospital who always walked to work in his white scrubs.

Then, there was the story of a drifter from Atlanta named Walter Yoo, a Cherokee who told authorities he was with the man who had abducted Judith Ann. They brought him down to Miami and found out he knew absolutely nothing about the crime scene. He had made it all up to grab the public's attention.

But detectives soon concluded the killer must have known the family's routine. This new theory only triggered new and more troubling questions. How did the killer know which car would

start with the keys taken from the grandfather's pocket? And how did the killer know that the grandfather kept his car keys in his pants? Why did the intruder ignore Judith Ann's little sister, Betty, sleeping by the unlocked rear door, where the killer had likely entered? And why didn't Judith Ann scream?

Police started looking closer to home. "All members of the family are under suspicion," announced frustrated Dade State Attorney George Brautigan. "This is a heinous crime. It had to be committed by someone who had knowledge of the house."

In late September, rumors spread that detectives were close to solving the case and a grand jury was being impaneled in Miami.

In a shocking turn of events, a prime suspect emerged: Roberts, the girl's father.

The burly Roberts had been local president, international representative and organizer for the UAW before becoming an attorney in 1950. He still represented the union and had political aspirations.

The Miami detectives sent to snoop into Roberts's life and background in Baltimore said that he had not been totally truthful. Roberts told police he didn't have any enemies that he knew of, and had not received any threats from anyone. But they heard talk that Roberts needed cash after his failed bid to enter politics. That maybe he had concocted a desperate plan to stage his daughter's kidnapping to extort money from his in-laws in Miami. But then the plot had gone terribly wrong and Judith Ann had to be killed, perhaps out of fear she would identify the person who took her in the middle of the night. It didn't help matters that Roberts, a supposed family man from all appearances, was bar hopping with a female client the night his daughter was abducted.

State Attorney Brautigan brought in witnesses who gave statements to the grand jury. Among them was a private detective who they would eventually stake their entire case on to make an arrest. The man told police he had seen Roberts near the murder scene the night Judith Ann was abducted. Based on his statement, in September 1954 the grand jury charged Roberts with the

murder of his daughter. Two other people, identified only as "John Doe" and "Mary Roe," were also indicted.

The surprise indictment splashed the story of the murder across newspaper front pages—again. Roberts, who by now had returned to his law practice in Baltimore, surrendered and was driven back to Miami to stand trial. He was released on bond three weeks later to await trial.

At this point, it seemed everything pointed to the girl's father. Even his own family members were convinced. At Roberts's bond hearing, Harry Rosenberg was asked if he had an opinion as to why the crime was committed. "Yes, I believe it was to have been a harmless kidnapping but something happened and she was killed." He said he felt one of the people involved was his son-in-law. He said Roberts had acted strangely after his daughter's murder, wanting to return to Baltimore right away and trying to avoid detectives' questions. A judge still released Roberts on a $10,000 bond.

They also questioned Dorothy Lawrence about her relationship with Roberts. Lawrence backed up his story, saying he had been with her, except for maybe a fifteen-minute period—not nearly enough time to carry out the crime. She also told them that on the drive down from Baltimore to Florida, James and Shirley Roberts had argued about James's womanizing in front of her.

It's easy to see why detectives eyed Roberts as a prime suspect. His actions the day before his daughter vanished didn't exactly make him dad of the year. He missed the pool outing in Coral Gables, didn't make it to dinner at his in-laws and wasn't home to tuck his daughters into bed. At his daughter's inquest, he told police he spent the day with Lawrence, meeting with another attorney and then helping her find a job. As Roberts told it, he and Lawrence made the rounds of local nightclubs. They had dinner on Biscayne Boulevard and then went on to the 1200 Bar at 1260 SW Eighth Street, just five blocks from the Rosenberg home. They chose the spot because they had hoped the owner, a friend of Roberts, would cash Lawrence's travel checks.

At the inquest, police asked Roberts if he had come home at any time that night; Roberts insisted he had not. "We stayed there

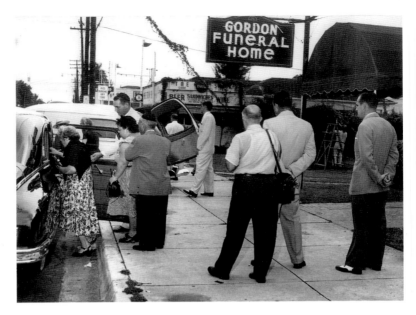

The funeral of six-year-old Judith Ann Roberts in 1954. Lead Miami Police homicide Detective Irving Whitman is the tall man shown leading the grieving family into a waiting car. *Courtesy of the* Miami Herald.

'till about 10:00 p.m. and then went to the Jungle Club to see what it looked like. We drove back to the Beach and went to the Circus Bar, then to the Paddock Club to see if they had a job for her. I believe we left the Paddock at about 1:45 a.m. and I took Mrs. Lawrence to the home of my sister-in-law where she was staying, then I drove back to the Rosenbergs and found everyone outside and Judy missing."

Asked if he thought his daughter's murder had been a sex crime, Roberts responded, "At first I felt it was. I couldn't imagine anyone else doing it—even if they had a grievance against me." He said the case was "very strange"—especially because someone had known to find the keys to Rosenberg's car in the back pocket of Harry Rosenberg's trousers that were on his bed post. "Certainly," Roberts said, "it must have been someone familiar with the movements of the family and the house."

The Unsolved Murder of Six-year-old Judith Ann Roberts

Then the prosecutions' case began to crack: Lawrence, the one witness who was with Roberts the night of the murder, came forward with allegations of witness intimidation. Lawrence charged that she was brought in by prosecutors who badgered and browbeat her into admitting that she had changed her story about seeing a rope in Roberts's car the day of his daughter's murder. She said two investigators with the state attorney's office had insisted she change her story. "They told me they knew Mr. Roberts had done it," she said.

The case was about to fall apart.

The private eye who had testified that he had seen Roberts in a club near the Rosenberg home at the time of the murder was found to be less than credible. His eyewitness account was thrown out. Then came another setback: the Florida Supreme Court issued a ruling that barred the use of Roberts's lie detector results, leaving prosecutors with no evidence tying Roberts to his daughter's murder. By December, charges against the girl's father were dropped.

Still convinced the killer knew the little girl well, investigators turned their attention on another family member. Their next suspect was Judith Ann's grandfather, Harry Rosenberg. Police felt they had enough evidence to bring a case against him, too. They hinted at some sinister allegations against him involving children in New York, but their most damning evidence was found in Rosenberg's Oldsmobile. When the car was found, the driver's seat was still pushed forward. Police surmised that whoever drove it last was very short. Harry Rosenberg was just under five feet tall. Their new theory: maybe the grandfather had tried to molest the girl and she had cried out.

The case against Rosenberg had one major flaw: how did the grandfather make it back home from Coconut Grove without a car? Detectives walked from where the body was dumped back to the Rosenberg's home and determined it was possible. "It could be done by taking some short cuts," Whitman said. But what about the statement taken from his wife, Dora, who told police that her husband was next to her in bed the night of Judith Ann's disappearance. Was the woman lying?

Harry Rosenberg was questioned repeatedly by detectives. An angry Rosenberg charged that police made him a prime suspect because he had complained bitterly about the lack of leads in the case. He, too, hired an investigator to gather evidence. Police never brought charges against Rosenberg, but it cast a shadow over the rest of his life.

Warren G. Holmes, a police sergeant at the time of Judith Ann's murder, was in charge of the Miami Police Department's lie detector bureau. He has long had a theory about Judith Ann's killer. He believes it was a sixteen-year-old boy who was picked up in the hours following the murder. The teenager was questioned at length by investigators but was released. "I'm totally convinced he is the killer," said Holmes.

Holmes had known the teen while working as a beat cop along downtown Miami's red-light district during the 1950s. "I think he saw the little girl through the window and had to have her," Holmes said, agreeing with Shirley Roberts's theory that her daughter had been grabbed by a child predator who had seen her dancing naked that night. He remembers the teen lived behind a drugstore near the Rosenbergs' home and that, under questioning, the teen admitted peering into the Rosenbergs' window. The teen was never arrested, but he stayed in Holmes's mind.

Then in 1964, a decade after the murder, Holmes said the teen's wife called police to say her husband confessed during a violent argument that he had killed Judith Ann Roberts. "I gave her a lie-detector test and she passed it," Holmes said. But when he gave the test to the man, he registered no emotion to questions, including whether he had killed Judith Ann. "It's as if he had ice water in his veins." Holmes is convinced the teen, who is now in his seventies, was Judith Ann's killer. "I know he did it," he said.

Forty-two years would pass before the Miami Police would take another serious crack at solving the murder of Judith Ann Roberts. In 2006, a band of detectives with the Miami Police Department's Cold Case Squad reopened the files and began tracking down old leads. They interviewed Whitman and Holmes, but came up empty. "We had a lot of supposition and conjecture, but we could

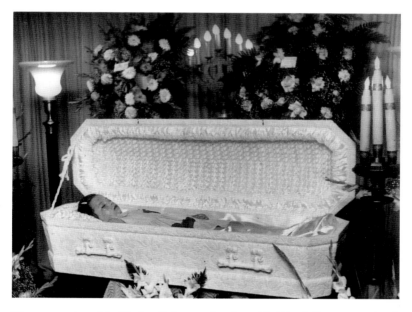

The open casket of Judith Ann Roberts at her funeral in Miami. She was murdered on July 7, 1954. Her murder remains unsolved. *Courtesy of the* Miami Herald.

never get a case tight enough against anyone to take it to a jury," Whitman said.

Today, the remains of Judith Ann Roberts are buried in a pink casket at Mount Nebo Cemetery in west Miami. It's the same place where mafia kingpin Meyer Lansky is also buried. The little girl would have turned sixty on August 9, 2007.

The Rosenbergs and James Roberts have died. Records indicate Judith Ann's mother, Shirley, and her younger sister, Betty, may still be alive. They have not spoken publicly about the case since the 1950s. Warren Holmes is now long retired from the Miami Police Department, but works for them as a consultant. He lives in nearby Broward County.

Whitman eventually left the Miami Police Department and became an attorney in Miami. But in an interview in 2006 it was clear the eighty-six-year-old former detective could not shake the memory of Judith Ann's murder. He still keeps copies of

investigative material from the case in his home office in Palmetto Bay, near Miami. And he still occasionally visits the site in Coconut Grove where Judith Ann's battered body was discovered so long ago. For all intents and purposes, he's still on the case.

He maintains that Judith Ann and her killer were not strangers. And he's kept three details about the murder a secret, things only the killer would know, just in case a suspect does emerge. The details could be crucial facts because little physical evidence is left of the murder scene. "Whenever a possible suspect pops up, I've come in and asked them those questions," he said. "No one has known the answers."

Miami—the Beginning of the End for Doors Legend Jim Morrison

The year was 1969. The place was Coconut Grove's old Dinner Key Auditorium. The headliner was the legendary rock band The Doors and their outlandish lead singer Jim Morrison. By all accounts, the performance on March 1, 1969, was forgettable—a lousy concert, some called it. Except for Morrison's reported explicit and explosive stage antics.

In the middle of his fourth and final song, Morrison exposed himself, briefly rolling down his tight, belt-less cowhide pants and flashing the family jewels to a raucous crowd of fans—or so Miami authorities alleged. Morrison followers, along with fans at the infamous Miami concert, say the twenty-five-year-old rock star known as the Lizard King did nothing illegal, certainly not enough to smear the career of the tortured genius.

"Nowadays, we would call it a wardrobe malfunction," said sixty-five-year-old Donald Bierman, who was then one of two young local attorneys hired to assist the singer's high-powered Beverly Hills lawyer, Max Fink. Bierman's theory: "I think he feigned exposing himself."

Back in 1960s Miami, local cops didn't see it that way at all. They charged Morrison with indecent exposure and other related

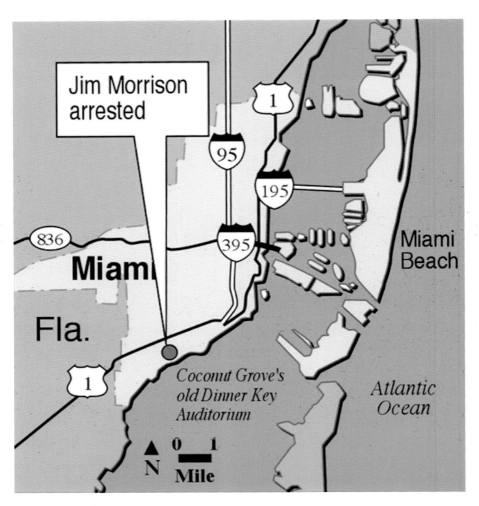

Courtesy of Dan Garrow.

offenses, setting in motion a legal battle that pitted prosecutors from a then conservative Southern city against a hard-partying rock icon at the peak of his success. Neither Morrison nor Miami would ever be the same.

The story of the birth of The Doors is well documented. Keyboardist Ray Manzarek and Morrison met as film students at the University of California in Los Angeles. They later hooked up in nearby Venice Beach in the summer of 1965 when Manzarek invited the charismatic Morrison, more of a poet than a singer, to join his group, Rick and the Ravens. Guitarist Robby Krieger and drummer John Densmore came on board later. Together, the four would leave a permanent stamp on American culture that still resonates today.

At the time of their Miami concert, The Doors had already staked their claim as a dark, progressive band with a charismatic, long-haired lead singer. They had released three widely successful albums: *The Doors, Strange Days* and *Waiting for the Sun*. Among their smash hits were "Light My Fire," "Break on Through," "Back Door Man," "Love Me Two Times," "Hello, I Love You" and "People are Strange." But now, the band was about to become even more notorious for their role in one of the most famous, and shortest, rock concerts in history.

The Doors appearance in Miami had been highly anticipated by their local fans. But they didn't know Morrison's image as a pretty boy lead singer was beginning to strangle him and that he was out to slay it. He had grown a heavy beard that partly covered his face; he had gained weight; and he was spending more time drinking than singing in the studio.

The band's gig in Miami barely garnered an inch of copy in the two local newspapers. But the tiny ads in the entertainment page had encouraged thousands to get tickets—or make plans to sneak in. Among them was Lorelei Loudis, then fifteen years old, of North Miami, who showed up at Dinner Key Auditorium that night without a ticket. She was hoping to at least hear the concert from the parking lot and said hundreds of other kids shared a similar plan.

Tickets for the concert were $6 in advance and $7.50 at the door. The Doors had been told they would play for six thousand fans for a $25,000 fee, said Morrison's manager, William Siddons, in a 2006 interview from his California office. At showtime, however, twelve thousand kids jammed the hall, well over the capacity of the hangar-like venue. It was estimated that a thousand more milled about outside.

Siddons blamed the fiasco on the promoter, Ken Collier—and on the local media. "Collier contracted us for a flat rate, but he pulled out seats and sold more than ten thousand tickets. He never paid us the additional fee for the higher gross he took in."

Collier was a scrappy Miami Beach entrepreneur. In the late 1960s, he ran the legendary rock club Thee Image in North Miami, which brought rock super groups like Led Zeppelin, the Grateful Dead and Jimi Hendrix to town. The club had been forced to shut down, and now Collier, along with his brother Jim, was trying to make a go at rock promoting. The two brothers should have stuck with their first business venture—a tanning lotion called Sunscrene. They had sold it to one of their top salesman in Daytona Beach. He renamed it Hawaiian Tropic and made millions.

For Morrison, the day he was supposed to perform in Miami had been a trying one. He had fought with his longtime girlfriend, Pamela Courson, and had missed his morning, non-stop flight from Los Angeles to Miami. His other band mates had made the flight. Morrison and Siddons were forced to wait for the next flight. As usual, Morrison turned to the bottle and kept drinking on the flight—and during a long layover in New Orleans.

"Jim was always drunk; that was nothing unusual that day," said Siddons, who knew the singer and the band's dynamics all too well. Siddons had started out as a teenage roadie. By age nineteen, he was The Doors's manager. In reconstructing Morrison's mindset that day, Siddons believes Morrison flashed the audience at the concert as an "artistic endeavor."

Morrison had gotten the idea after attending a Living Theatre performance at the University of Southern California. Living Theatre actors attempt to dissolve the fourth wall

between themselves and the audience. The relationship is not passive, but more confrontational. Siddons said, "Jim was fascinated with it. I went to one of the shows with him; he went to three more alone." Afterward, he told Siddons, "I'm going to talk to the audience more."

He did just that in Miami. "He got it in his head to take the show in a totally different direction that night. Of course, he didn't tell anyone. He was a true artist," Siddons said.

That visit to Florida was to be a sort of homecoming for Morrison. Born in Melbourne, Florida, the son of a U.S. Navy admiral, he attended St. Petersburg Junior College and Florida State University before heading west to launch his poet-as-rock-star career. He had left the state and his troubled relationship with his father and never looked back.

Morrison did not arrive at the auditorium until around 11:00 p.m., and he downed two Buds before taking the stage. The Miami crowd had been growing impatient and unruly. A boozy-sounding Morrison finally took the stage. He first tried to get through "Break on Through" but stopped in mid-song for a riff. He then pointed to those in the back who had bad seats and urged them to move forward. Those who were close to the front felt the crowd behind them pushing forward, shoving them near the stage.

Morrison continued his drunk chatter. "I'm not talking about a revolution, I'm not talking about a demonstration. I'm talking about a good time! I'm talking about a good time this summer. You all come out to LA and we'll lay down in the sand. We'll rub our toes in the ocean and we're going to have a good time. Are you ready? Are you ready?" Simulating a climaxing scream, he shouted, "Get it up baby!"

The music started up again and Morrison began heaping insults on the crowd. "You're all a bunch of fucking idiots!" Morrison yelled. The crowd murmured amongst themselves, unsure if the rock star was kidding. "Letting people tell you what you're gonna do. Letting people push you around. How long are you going to allow it?" Morrison continued during his attempt to sing "No One Here Gets Out Alive."

"Your faces are being pressed into the shit of the world. Maybe you love it," he said as John Densmore continued to play a backbeat on his drums. "You are all a bunch of slaves, letting people push you around. What are going to do about it?" he said over and over again, capping it off with a primal scream.

Some in the crowd grew angry, shouting "fuck you, Morrison, you creep!"

Then, he began to plead with the audience as if they were his lovers. "Hey, I'm lonely. I need some love. I need some southern good loving. I can't take it without good love. Ain't nobody gonna love me, come on? There is so many of you out there. Nobody gonna love me, sweetheart? I need it."

Then came a bizarre moment, the first of many on this particular night. At some point, someone handed Morrison a baby lamb, which he caressed. Some thought he simulated sex with the lamb. Others in the audience thought he would sacrifice it. Morrison gave it back to its owner and continued. A bottle of champagne got handed to him. Morrison went over to a Miami cop, snatched his cap and threw it into the audience. The cop grabbed Morrison's floppy leather hat and did the same.

He continued talking: "Hey, there is a bunch of people back there that I didn't notice. How about you 50 or 60 people come over and love my ass!" The invitation seemed to be for both women and men. At some point, a girl jumped on stage and grabbed Morrison's crotch. "You want it?" he yelled at the crowd.

"People kept saying 'this show is really weird,'" remembers Siddons. Loudis, the teenager listening in the parking lot, agrees. She eventually sneaked in along with hundreds of other kids when one of the large garage-style doors of the auditorium was mysteriously opened. "You could do stuff like that back then, but it was the one time I hated being 4'9. I missed all the peccadilloes on stage," she said. "People around me were saying 'look what he's doing.' To this day, I remember a rumor in the crowd that he had brought a baby lamb on stage and was beating off on it. People were really surprised at what he was doing. Today, it wouldn't be such a big deal but back in the day, it was shocking. It did cause a stir in the audience."

The Beginning of the End for Doors Legend Jim Morrison

When the band began playing, Morrison again stopped singing. He shouted, "Stop. Stop. This is fucked up! You blew it!" The onlookers were unclear as to whether he was referring to the band or the restless audience. The audience's catcalls only intensified as the band began to play its most famous song, "Light My Fire." Morrison stopped singing again. Finally, he allegedly asked, "Do you want to see my cock?"—and made rock history.

Theodore Jendry, fifty-nine years old, was one of twenty-six off-duty Miami officers hired to control the crowd at the concert. Jendry claims he saw Morrison's private parts. "Morrison pulled out his business and started whirling it," said the retired Jendry, who now lives in Deerfield Beach. "He should have been arrested right there. He kept trying to incite those kids."

Miami Beach teen David LeVine, now in his fifties, was at the foot of the stage with his camera. "I had come expecting to shoot a baby-faced Morrison and was disappointed to find he had a bushy beard and you could hardly tell it was him," said LeVine, a Miami Beach High graduate hoping to launch a career as a rock photographer. By showing his camera gear, LeVine managed to get into the concert for free.

"The Doors started to play and boy were they bad, off tune and all," LeVine writes on his own website. "The band started to get rowdy and the crowd soon followed, charging the stage and almost crushing me. I remember thinking that if I had paid $7.50 for a ticket I would have been really pissed off." One of LeVine's pictures, later presented in a Dade County courtroom at Morrison's obscenity trial, showed Morrison with his hand near the crotch of his pants. "Never saw him expose himself, though," said LeVine, who testified to that effect and ended up taking exclusive photos at the trial of Morrison, which he sells on his website, treeo.com.

Loudis, now fifty-five years old and living in Ocala, doesn't remember hearing that Morrison had exposed himself until later. "I just know that all of a sudden he was off the stage." Siddons, too, said he missed the alleged felony. "That night I was chasing after the promoter trying to get paid." He learned later the significance of the evening. "It was a show unlike any other.

It was completely chaotic, but I didn't get that until I listened to a tape later."

Collier, the promoter, jumped on stage to stop the concert; Morrison pushed him off. All mayhem broke out as the crowd pushed forward. Morrison said he left the stage by jumping into the audience and then going up the side stairs to the balcony. Police rushed the stage and shut down the concert—after only four, half-sung songs.

Collier always blamed The Doors for inciting that night's pandemonium in Coconut Grove. "I couldn't help what the Doors did," Collier said six months after the concert. Collier has since passed away.

Morrison was not arrested the night of the concert. That night, he left in a limo with the band and Siddons. On the ride back to a Miami Beach hotel, Siddons remembered Morrison telling him "uh, oh, I might have exposed myself out there." Siddons said that Morrison knew he had gone too far. Siddons innocently repeated the line the next day to *Rolling Stone*. "That's before I knew to be careful with what I said to reporters," he said. "We didn't think anything of it. It was no big deal. And what if he did? It was only for a tenth of a second. He didn't do it for prurient reasons. It was theater, but it happened in Florida, a real black and white state, and it was the south."

Siddons blames the *Miami Herald* for raising a ruckus over Morrison's alleged exposure. "A reporter at the paper is the one who called the police chief and other community leaders asking what they were going to do about Jim exposing himself. Nobody else realized it. The *Miami Herald* is to blame. That's why the incident became something. It would have just been another weird show, but the incident was galvanized by the newspaper which got the political machine going." Siddons said the paper even made it appear as if Morrison had run out of town to avoid charges. "The last line in their first story about the exposure said Morrison and his entourage 'escaped to the Caribbean'—that vacation had been planned for weeks!"

While all were sunning in Jamaica, the backlash against Morrison in Miami and across the country picked up steam. Radio stations blackballed The Doors, refusing to play their songs. Local

conservative and religious groups quickly hatched a plan for what was to be called Miami's Decency Rally at the Orange Bowl, which had been the site of Super Bowl II (1968) and Super Bowl III (1969). Backed by the Archdiocese of Miami, local teens organized the event. Among those taking part was singer and Florida orange juice pitch woman, Anita Bryant. Eight years later, Bryant would reemerge in another family values campaign that would also make local history. She would spark a furor by leading a campaign to repeal Dade County's anti–gay discrimination ordinance.

Some thirty thousand people, many strait-laced teenagers, filed into the stadium to hear speeches denouncing The Doors and the depravity promoted by rock-and-roll. In a way, the rally offered a glimmer of the birth of the Moral Majority. The two teens picked as local representatives were featured in newspaper stories. Even President Richard Nixon called to congratulate the organizers.

City officials took the syrupy rally as a public mandate. Morrison, in the eyes of Miami, had broken the law. Six obscenity charges were filed against Morrison on March 5, 1969, four days after his infamous concert. Prosecutors even found an employee in the State Attorney's Office who had attended the concert to bolster their case. Morrison turned himself in to the FBI in Los Angeles on April 4, 1969, and was released on bond. A trial date was set for August 12, 1970.

Morrison and Miami would soon be under a media microscope. Morrison's trial ran through September and took place in the Metro Justice Building near downtown Miami. A mob of fans packed the courtroom the first day.

During breaks, Morrison walked freely along the courthouse hallway signing autographs and greeting young well-wishers who were out of school for the summer. Following instructions from his attorneys, he usually dressed conservatively—for a rock star—and carried a journal where he wrote down his impression of the proceedings. The other Doors members flew to Miami for one day to show their support. A photo of the group members at the courthouse appeared in the morning newspapers.

But the damage was already done; The Doors were a wounded band, recalls Siddons. "Everything got canceled. I would have

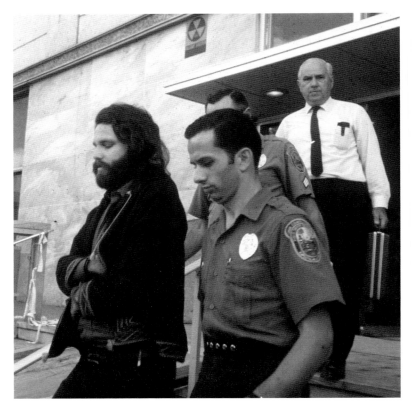

Doors lead singer Jim Morrison is led outside the Dade County Courthouse following his arraignment on charges of obscenity in 1971. *Courtesy of the Miami Herald.*

continued my life managing a pretty good band. Instead, we became pariahs. We were never the same. Instead of trying to create a new universe, from there on people thought Morrison was a weenie waver. We were fighting for our very right to perform. We were always on the defensive."

Morrison was defended by Fink and local attorneys Robert Josefsberg and Bierman. A jury of four men and two women, all over forty years old, were picked to decide Morrison's fate. The prosecution team, led by Assistant State Attorney Terry McWilliams, had three future judges aboard: Ellen "Maximum"

Morphonios, Alfonso Sepe and Leonard Rivkind. The blonde and brassy Morphonios would become famous for handing down tough sentences to criminals. Sepe would be caught taking bribes in a sting, dubbed Operation Court Broom. Now retired from the bench, Rivkind, seventy-nine years old, recalled the state had a solid case. "We had a number of witnesses who testified they saw him do it," he said.

On September 16, 1970, Morrison took the stand. But he didn't help his defense much with his sassy attitude. Witness the exchange between Morrison and prosecutor McWilliams below.

McWilliams asked if the singer wore skintight, tailor-made "cowhide pants to give maximum exposure of your genital area?"

"Huh uh," Morrison answered.

"Yes or no?" McWilliams insisted.

Morrison: "No."

McWilliams: "Isn't it a fact you were bumping into your instruments [because you were drunk on stage]?"

Morrison: "I don't play an instrument. I don't even get near them."

McWilliams: "Your singing that night, wasn't it off?"

Morrison: "I'm sure that you are aware that that is just a matter of opinion...some people think I sing off key but I don't and some people might think I sing off time. I might not."

Morrison said he had been heckled by the audience too.

McWilliams tried to get Morrison to say he had exposed himself because he was angry about having his sexuality questioned. But Morrison didn't bite.

"Some people in the audience called you a fag, isn't that correct?" McWilliams asked.

"I don't remember that specifically," Morrison said.

"It disturbed you, didn't it, that someone would call you a fag?" McWilliams continued to push.

"Not particularly, no," Morrison said.

"Doesn't that insult your manhood?"

Morrison said, "Well I think any allegation like that generally says more about the person that calls the epithet rather than the victim."

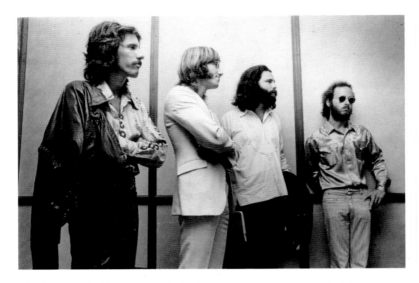

Members of The Doors appear in Dade County court to support their band mate, Jim Morrison. Standing from left to right: John Densmore, Ray Manzarek, Morrison and Robby Krieger. *Courtesy of the* Miami Herald.

McWilliams took another tact. "Did you say to the audience, 'you're all a bunch of fucking idiots. Your faces are being pressed into the shit of the world. Take your fucking friend and love him'?"

"Yes, I said that."

"Do you admit that you said, 'Do you want to see my cock?' as witnesses have testified?"

"No," Morrison shot back.

More than thirty-six years later, at least one concertgoer, a prosecution witness, has changed his story about what he saw that night.

Karl Huffstutlear, now fifty-six years old, then nineteen, was among a handful of witnesses who testified that Morrison pulled down his pants. Reached in 2006 at his Lake Placid, Florida home, Huffstutlear said, "I didn't see anything come out of his drawers. To me, it's still a mystery what happened." Huffstutlear said he testified he saw Morrison expose himself to match his then fiancée's story. The two eventually married.

The Beginning of the End for Doors Legend Jim Morrison

Huffstutlear, a retired Fort Lauderdale electrician, went to the concert with Colleen Clary, whose brother-in-law was one of the off-duty officers at the concert that night and had let the couple in for free. The pony-tailed Clary, embarrassed by the questioning, tearfully testified that Morrison exposed himself. Clary testified she saw Morrison roll down his tight pants to a spot midway between his waist and knees, then place his hands on his exposed penis. She said the whole thing lasted about ten seconds.

In the end, the jury convicted Morrison of only two misdemeanors: indecent exposure and open profanity, and acquitted him of a more serious felony charge and other misdemeanors. It was a mixed verdict for the famed rock star. "He wouldn't be convicted today or even charged," said his Miami attorney Josefsberg, now sixty-seven years old. "You hear worse language today in rap songs."

Josefsberg remembers Morrison fondly. "He was a very intelligent young man I really liked. We spent some time together preparing for trial and I found him to be nothing but charming." But Morrison's bad rep haunted him. One Sunday, Josefsberg invited Morrison to come over to his house to prepare for the next day in court. "He came over, but not before my wife insisted on taking our young children out of the house," he said.

Josefsberg has one regret. Years after the trial and after Morrison had died, the attorney was cleaning out his garage. He came across the boxes and boxes of testimony, photographs and evidence from the trial. "I threw them out. Can you believe it?" But he does have one memento. The singer gave him a signed copy of his poetry book, which Josefsberg still owns.

On the morning of October 30, 1970, Morrison appeared in court to receive his sentencing from Circuit Judge Murray Goodman. The punishment: six months in jail and a $500 fine. Goodman also gave the singer a tongue-lashing, blaming Morrison for promoting a decline in morality standards: "The suggestion that your conduct was an acceptable community standard is just not true...To admit that this nation accepts as a community standard the indecent

exposure and the offensive language spoken by you would be to admit that a small minority who spews obscenities, who disregard law and order and who display utter contempt for our institution and heritage, have determined the community standards for us all."

Morrison was not surprised by the stiff sentence. Before Goodman walked into the courtroom, Morrison had told reporters he fully expected to get the maximum penalty for the misdemeanors. But said he hoped to win on appeal and remain free. After the sentencing, a stern-faced Morrison walked out of the courtroom appearing more like a lumberjack than the Lizard King. "Jail— that's a bad place," Morrison told reporters outside the courtroom as photographers snapped pictures. He then flew back to Los Angeles never to return to Miami again.

The conviction proved a fatal blow to Morrison and his band. Promoters shunned them, fearing more X-rated stage antics. The band stayed in the studio, performing just one last concert in New Orleans. Like a true bohemian disenchanted with his life in America, Morrison moved to Paris with his longtime girlfriend. "Jim felt he was becoming a puppet of the public, who saw him as this dark sexy guy," said manager Siddons. "He was trying to escape being a sex object." Morrison was trying to reinvent himself as a poet. "He got fat and grew a beard and said: 'Fuck it, I'm going to Paris.' We said, 'OK, have a good time.' He never came home," Siddons added.

Early on the morning of July 3, 1971, the hard-drinking Morrison was found dead in his apartment from an apparent heart attack. He was twenty-seven years old. Even in death, Morrison became embroiled in controversy. A slew of postmortem rumors began. Courson told authorities that Morrison had decided to take a bath the night before and that when she woke up the next morning, she discovered his body floating in their tub. Courson, who died in 1974 of a heroin overdose, helped fuel rumors that something was not right when days later she told the media that Morrison was not dead but hospitalized.

Adding to the mystery, no autopsy was performed on Morrison. A French doctor signed his death certificate and plans were quickly

The Beginning of the End for Doors Legend Jim Morrison

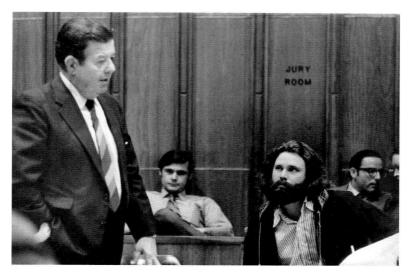

Jim Morrison listens to his Beverly Hills attorney, Max Fink (left), speak in a Miami courtroom on October 30, 1970, the day he was sentenced. *Courtesy of Bill Sanders, a Miami Herald photographer.*

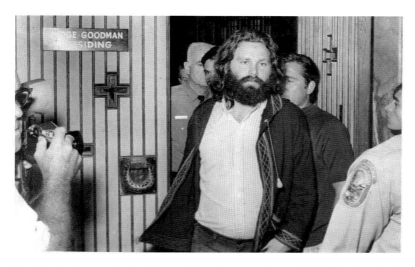

Jim Morrison leaves the Dade County Courthouse on October 30, 1970, after a local judge sentenced him to six months in jail and a $500 fine. He appealed it, but died before the case could be reviewed by a higher court. *Courtesy of the Miami Herald.*

made to bury him at the historic Pere-Lachaise Cemetery, resting place to Balzac, Chopin, Edith Piaf and Oscar Wilde. His coffin was sealed before Morrison's family or U.S. Embassy officials could identify it.

One last rumor is that Morrison had really died of a drug overdose in a sleazy nightclub and had been brought back to his Paris apartment and put in the tub in a failed attempt to revive him. In *Break on Through to the Other Side: The Life and Death of Jim Morrison*, the authors, James Riordan and Jerry Prochnicky, suggest that Courson told others that Morrison found her stash of heroine, snorted it and overdosed. Morrison disliked needles. Somehow, Courson managed to convince the French doctor that he died of a heart attack to avoid the media circus that would have turned Morrison into the third rock star in eleven months to die of a drug overdose—Janis Joplin and Jimi Hendrix were the first two. She failed.

Others believed that Morrison faked his own death to be free of the burden of fame. Sightings of the singer were allegedly reported in Los Angeles and Paris. Siddons, who flew to Paris after Morrison's death to get the real story, said: "I believe what Pam told me about the way he died. Pamela was the love of Jim's life. The only woman he kept coming back to. She told me she was the only person who stood up to him. I think she was right. I certainly never stopped the guy and slugged him when he was doing destructive stuff."

Today, Morrison's grave is covered with flowers and surrounded by visitors, young and old, from all over the world.

For Siddons, who went on to manage America, the Band and Crosby, Stills & Nash, the chance to work with Morrison was a rare musical experience. "He was the purest artist I ever met." Siddons said, "He had one mission in life: to be the greatest he could be. His frame of reference was totally different from yours and mine. He was able to reach into his spinal cord and shake people in a very special way." As for the Miami concert, Siddons said it simply represented a sad chapter in the band's storied rise to the top of the rock 'n' roll music industry. "The Miami concert was pretty much the end of The Doors as we knew them."

Epilogue

At the time of his death, Morrison's Miami conviction was still under appeal. But in March 2007, with the election of new Florida Governor Charlie Crist, a group of Jim Morrison fans organized to win him a posthumous pardon of his 1970 conviction in Miami-Dade. Dave Diamond and Kerry Humphreys, fans from Ohio, co-wrote a letter to Crist requesting Morrison's name be cleared. Even Morrison's eighty-seven-year-old father, U.S. Admiral George S. Morrison, who seldom spoke of his son publicly, joined in the crusade. The letter reads,

> *Dear Governor Crist,*
>
> *It is with great honor and profound respect that I write you. Justice has been denied to a native Floridian and the time has come at this point in history to correct a wrong that occurred in 1970 in Dade County Criminal Court.*
>
> *James Douglas Morrison was born 12-08-43 in Melbourne, Florida. Jim Morrison was the son of Admiral George Stephen Morrison and Clara Clark Morrison, who met in Hawaii in 1941 where Steve Morrison, then an ensign, was stationed.*
>
> *This letter is a special request for a Posthumous Pardon, full and absolute for James Douglas Morrison, almost thirty-seven years after he was convicted in a politically turbulent climate in Dade County in the late Sixties. It is being requested of you to review this case and take action to correct these proceedings, since this case has been sitting unresolved on the law books for far too long. There are two precedents that are being presented to you in this letter for your consideration.*
>
> *The Doors were scheduled to play a concert at the Dinner Key Auditorium on March 1, 1969. The Doors manager, Bill Siddons had made a deal with the Miami promoter, Ken Collier to accept a flat fee of $25,000 instead of sixty percent of the gross receipts.*

Collier then sold between eight to nine thousand tickets at more than the agreed price. Collier also removed seats to allow more people into the auditorium. An auditorium designed to hold seven thousand people was now packed tight with about thirteen thousand.

Jim Morrison missed his scheduled flight into Miami and spent the time waiting for the next flight, drinking in the airport lounge. Once he boarded the plane he continued drinking. During a stopover in New Orleans he missed his flight again and consumed even more drinks waiting for the next flight. By the time he reached Miami he was extremely drunk. Once he took the stage he was almost falling down drunk. He was abusive towards the audience, he would start a song only to stop it after a few lines, he would consume even more drinks from members of the audience. He allegedly then exposed himself for a brief instant and continued on with the show.

The next day The Doors started a planned vacation. While out of the country, the press in Miami had a field day with the alleged exposure incident. Pressure was put on local officials to do something about it. On March 5 1969, Bob Jennings from the state attorney's office acted as complainant. A warrant was issued for the arrest of Jim Morrison on one felony count of lewd and lascivious behavior and three misdemeanor counts of indecent exposure, open profanity and drunkenness.

Jim turned himself in to the FBI in Los Angeles on April 4, 1969. On November 9, 1969, he entered a not guilty plea in Miami. The trial did not start until August 12, 1970. Max Fink was Jim's defense lawyer, the prosecutor was Terrence McWilliams and Judge Murray Goodman presided over the case. Much evidence was heard from witnesses for both sides. Most of it was contradictory. On September 20, 1970, the jury found Jim Morrison guilty on the misdemeanor charges of indecent exposure and profanity. He was found not guilty

on the felony charge and the misdemeanor for drunkenness. He was released on a $50,000 bond and returned to Miami on October 30, 1970 for sentencing.

Judge Goodman sentenced Jim to six months of hard labor and a $500 fine for public exposure and sixty days of hard labor for profanity. The sentences would run concurrently. He would be eligible for release after two months and would be on probation for two years and four months. His lawyer filed an immediate appeal. Until the appeal could be heard, Jim would be free on the $50,000 bond.

It was never actually proven with photos, video or audio recordings or documentation that Mr. Morrison had indeed exposed himself. Under oath, he denied doing so and there were no witnesses who could say with 100% certainty that he committed such offense. There is no dispute as to the drunken language that he used in between songs at this particular concert. One must take into account, he was a performer at a rock concert and not preaching at a church or giving a speech at a political function.

Jim Morrison was to die in Paris, France July 3, 1971 before his legal problems could be resolved.

In December 2003, the Governor of New York George Pataki issued a full Pardon to Lenny Bruce for all convictions resulting from his 1965 obscenity trial, declaring the State of New York has a profound respect for the First Amendment and free speech must be protected. Jim Morrison was convicted along the same lines and by today's standards, Mr. Morrison's actions and verbal commentary on that August night are tame compared to some of the more notorious recording artists of recent years who have done far worse in terms of theatrical performances. Frankly, Mr. Governor, I've seen and heard comedians use worse language at local comedy clubs here in Ohio and I've certainly never witnessed State, City or County officials rushing to bring comedic performers to trial as was the case with Mr. Bruce.

The most important precedent comes from a recent ruling from Houston, Texas where former Enron founder Ken Lay was found guilty of various charges, but Mr. Lay passed away before his appeal could be heard. His passing resulted in the sitting trial judge having no choice but to abate the case against Mr. Lay on October 17, 2006.

Jim Morrison died in Paris, France in July of 1971, but his appeal has not yet been heard from 1970 to present day. This is the primary reason why this matter is being brought to your attention.

A citizen of Florida has been denied justice and the Morrison family have been living with this unresolved case for almost forty years. Very simply, Mr. Governor, it is time to correct the wrongs of this case and issue a full Pardon to James Douglas Morrison and abate Case# 69-2355 off the Florida record.

Thank you for your time in reviewing this case. Your immediate action is requested after many years of long wait.

Respectfully submitted,
Dave Diamond Dayton, Ohio jimi69guitar@hotmail.com
Kerry Humphreys Orem, Utah (PH) 1-800-891-1736

Crist, as of late summer 2007, had not acted on the request.

Murder of a Union
Boss in Miami

In the early hours of Sunday, February 6, 1972, Joseph Caleb, a union organizer and hero to generations of working-class blacks in Miami, stood near his flashy black 1971 Lincoln Continental in the parking lot of a north Dade County apartment complex. That night, the married father of four had driven back from a business trip to Orlando and had just dropped off a female friend. Before getting behind the wheel, Caleb, thirty-four years old, apparently took a Polaroid camera and an empty flask of wine from the backseat of his car. With keys in his hand, he headed to his trunk to place the items inside.

Caleb, who always carried a gun because he suspected someone wanted him dead, left his loaded gun on the front seat. His killer or killers were lurking nearby. In an instant, they came up from behind and fired one shot into Caleb's back. He turned toward them, and the bullets kept coming. Two. Three. Four. Five. Six. In all, six bullets ripped through Caleb's body. He then fell on his back on the pavement next to the rear bumper of his car.

By all indications, the ambush slaying looked like a professional hit on the man who led the nation's second-largest local union and

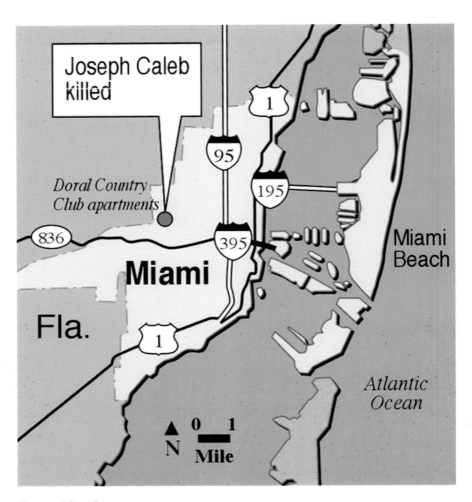

Courtesy of Dan Garrow.

Murder of a Union Boss in Miami

South Florida's largest union—the predominantly black Laborers' International Union of North America, Local 478 (AFL-CIO). Who had wanted the flamboyant labor boss dead? Was Caleb the victim of union infighting? Was it a mob hit? Did somebody think he had gotten too big for his britches? Or was it personal?

One thing police could dismiss as a motive was robbery. Two rolls of cash in Caleb's socks were untouched. Police found $731 in the left sock and $16 in the right one. Dade County homicide detectives found few pieces of evidence, suggesting the hit had been clean and carried out by a professional or, at the very least, someone who knew not to leave any clue behind.

The list of possible union enemies was endless. Caleb, police soon learned, had ticked off plenty of people around town as a union boss. That's why he always carried a gun. For police, the investigative journey would require them to go back in time to the early 1960s to learn more about a young black man—the grandson of an Alabama sharecropper and son of a single mom—who would rise to power as a union organizer in the midst of this nation's civil rights movement.

Caleb had always grappled for respect, regardless of his color. His rebelliousness is what brought him to Miami. As the family story goes, after graduating from a Savannah high school in 1956, Caleb married his sweetheart, Yvonne, and went to work at a restaurant. He would have probably remained there, toiling as an unskilled laborer the rest of his life, but one day Caleb and his fellow employees were taking a break out back and horsing around when a white female employee pulled a chair from under Caleb, causing him to fall down to the amusement of the others.

Embarrassed and angry, Caleb jumped up and slapped her—a serious offense for any black man in the South. Fearing for his safety and freedom, his family urged him to pack up and leave town. But where to go? What about his cousin in Miami who worked as a longshoreman? Convinced his cousin could get him a job, Caleb headed for Overtown, a predominantly black section of Miami. He eventually brought his wife and rented a small apartment.

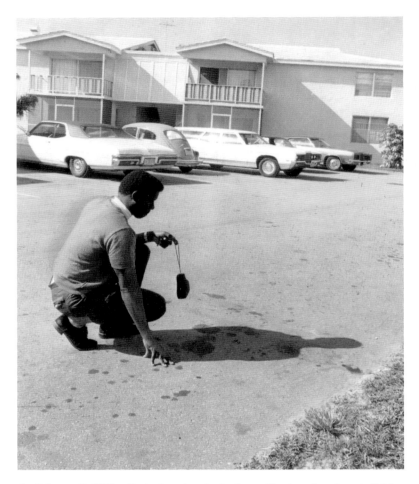

On February 7, 1972, a Dade detective checks the parking lot where Joseph Caleb was murdered. *Courtesy of the* Miami Herald.

Murder of a Union Boss in Miami

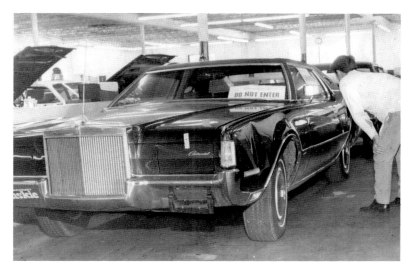

Joseph Caleb, a Miami union organizer was shot and killed on February 6, 1972, outside a Dade County apartment complex. Police later brought the car, a late-model Lincoln Continental, into a garage to keep as evidence. *Courtesy of the* Miami Herald.

At first, times were hard for the Calebs. After working for $2 an hour as a scab stevedore for nearly a year, he found a steady job pouring concrete at a south Dade plant for $1.50 an hour. It was no doubt less money, but at least it was his own job, not someone else's. Caleb worked twelve-hour days to support his family. But he wanted better. He tried construction work and, in 1958 at age twenty-one, landed a coveted job at a major Miami Beach work site: the building of the Southgate Apartments at 900 West Avenue. The job would change the course of his life.

One day, as a rank-and-file laborer, he heard that the black foreman on the job was to be replaced by a white one. "We were halfway completed when they sent a non-black in to supervise. There was a rumor that we hadn't done this, or we hadn't done that and they were going to fire the black foreman," Caleb told a reporter years later, recalling the moment his meteoric rise in

the union began. "I took the position that if they fired him, we were all leaving."

What happened next was almost reminiscent of the Oscar-winning 1954 movie, *On The Waterfront*. In this case, Caleb was Terry Malloy, the character played by Marlon Brando who stood up to the mob bosses running the longshoremen's union. Angered by the firing of the foreman, Caleb led a successful walkout. "When the whistle blew that morning, I told all the guys to keep on shooting dice. And they kept right on shooting. I was sitting by the street reading the newspaper," he told the reporter.

Because of the brouhaha at the work site, the union honchos came down to talk to the workers. Caleb spoke up in defense of the fired foreman and was joined by the other black workers. That day, a leader was born.

Most impressed with Caleb's self-confidence was Bernard Rubin, a mob-connected labor leader. He was president of the Southern Florida Labor District Council, an umbrella bargaining agent for locals from Dade to Broward to Palm Beach Counties. He also happened to be Local 476's business agent—or the guy whose job was to fatten the union's coffers. Rubin was struck by Caleb's ability to inspire older workers and persuade them to follow his lead. He wanted Caleb on his team.

There was another reason Caleb caught Rubin's eye, according to a retired federal investigator who was a member of a U.S. Labor Department strike force created in Miami to investigate unions. Men like Rubin were smart enough to realize times were changing in America—and in the workforce. "We heard that the unions were having a lot of problems with the rank-and-file workers who were beginning to question why all the union leaders were white and most members were black. They wanted to be let in too," said the retired agent.

Caleb offered a solution, and Rubin took him under his wing. Caleb was promoted to shop steward. A year later, he was elected recording secretary and permanently traded in his work clothes for a suit and tie. The gregarious Caleb was a hit with the membership. He ran for president in 1963 and won. He was

Murder of a Union Boss in Miami

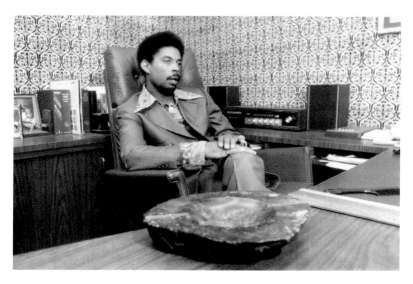

Joseph Caleb in his union office in 1972. He led the nation's second-largest local union, the predominantly black Laborers' International Union of North America, Local 478 (AFL-CIO). *Courtesy of the* Miami Herald.

barely twenty-seven years old. As president of the large Teamsters local, still housed today at 799 NW Sixty-second Street, Caleb swelled its dues-paying membership from four hundred to six thousand, making it the county's largest and giving him control of almost every local muscle worker.

The tall, lanky, six-foot Caleb, sporting a full Afro, cut an imposing figure in Miami-Dade's white power circles at a time when blacks were making gains. In his white Edwardian shirts, usually topped by a purple, orange or red mod suit, colorful scarves and pinkie rings, Caleb made an impression when he walked into any meeting. He was just a sign of the times. It was the 1960s—the age of black power, of be black and be proud. And Caleb was living it and shoving it in the faces of those who didn't like it. He was black, smart and well aware of the power he held as a leader.

Caleb quickly cemented his authority in the union becoming the champion of the little guy, the working hard-hat. However,

he wasn't so popular with Miami's construction business leaders, who had to negotiate with the tough-as-nails Caleb about the hourly rates of workers. Caleb started forming alliances with other powerful blacks in Miami-Dade.

Among his closest friends was T. Willard Fair, who today still heads the Urban League of Greater Miami.

They found themselves as the two most powerful black men among the city's white power brokers—Caleb with the labor unions and Fair with community action groups. They were both pushing for the advancement of blacks in Miami-Dade. Both could rally support at the drop of a hat.

"We were both angry young men at the cusp of the civil rights movement fighting the system. And we both loved to wear these wild outfits," Fair recalled. Fair said Caleb's appeal was basic. "It didn't matter how powerful he got, Joe never lost the common touch." Friendly and funny, he was always surrounded by a crowd. "Not because he was afraid for his safety, he just loved people," said Fair, now in his sixties.

Caleb cultivated influence as a rainmaker, learning quickly from the labor bosses that came before him. He did favors. He paid bail and late rent. He put food on empty tables. Most of the funds came out of his own pocket. When he died, Caleb was making $35,000 a year in salary and perks—a good salary for the time. "His men, as he affectionately called them, repaid him with their loyalty," Al Huston said. "Joe made the union powerful, but he really cared about people; it wasn't just about our work, he wanted the quality of our lives to improve. The men loved him for that." Huston, now sixty-one years old, was Caleb's protégé and is the current president of the same union, renamed Local 1652.

During his tenure, Caleb created his union's pension plan and its scholarship program for the children of workers. He funded summer youth programs. He staged pro-worker demonstrations. From 1963 to 1972, the hourly wages for union members more than quadrupled, from $1.15 to $5.30 an hour—and that was life-changing for some. It made him a hero with his men, but

placed Caleb at odds with white contractors and developers who balked at his demands for "union-only" work sites and higher and higher wages for his men.

Once, during deep negotiations with a white contractor, the man complained that he felt discriminated against by Caleb, recalled Caleb's son, Stanley. "Try waking up black," the labor leader shot back.

Caleb wanted the best for his men, Huston said, retelling a favorite Caleb story. In the late 1960s, Miami Beach nightlife was hot, but those dining and dancing in fancy hotels were not working-class blacks. "One day, Joe announced that the union was going to host its annual Christmas party at the Fontainebleau Hotel. Us at the Fontainebleau!" Huston recalled with a chuckle. "Everyone got dressed up with their wives and headed for the hotel. They served us steaks and he put a bottle of liquor on every table. He made us feel special."

Caleb evolved into a man to contend with, an effective community activist who rubbed shoulders with politicos and power brokers alike. The Dade Better Government League voted him Outstanding Citizen in 1971. He was elected head of the Model City Advisory Board, an ambitious federal program to overhaul blighted black neighborhoods. Caleb's political contacts grew ever more impressive, from the late Gwen Cherry of Miami, the state's first black female legislator, to U.S. Senator Claude Pepper, the longtime state lawmaker. And Caleb was channeling his union's support even higher, to 1972 Democratic presidential candidate Edmund Muskie, who publicly thanked Caleb during a Miami stop, as did Senator Birch Bayh of Indiana, who would run unsuccessfully for president in 1976.

But Caleb's murder torpedoed the union juggernaut he helped build. "The union was never the same," Huston said. Stanley Caleb, who was thirteen when his father died, said his family life also unraveled. "My father's death destroyed us; it's like the lights went out," he said. "I know my life and that of my two sisters and brother would have been different if he had been around."

To help the Calebs, the union bought out the $32,000 mortgage on the family home on NW Ninety-first Street. Yvonne Caleb, who

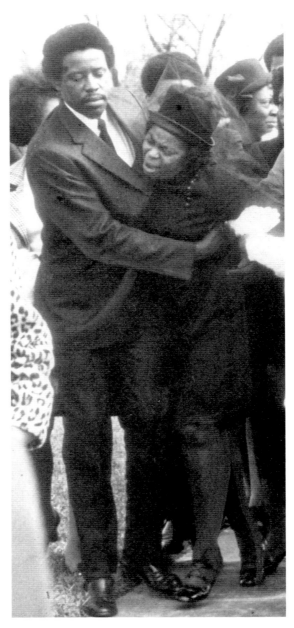

Joseph Caleb's widow, Yvonne, grieves at his funeral on
February 10, 1972. *Courtesy of the* Miami Herald.

never remarried and declines interviews with the media, still lives in that same home she shared with her husband.

The crowd for Caleb's viewing on Thursday, February 10, 1972, was expected to be so massive that it was held at the Dade County Auditorium on West Flagler Street. Some 2,500 mourners attended. Thousands more walked past his greenish bronze casket as he lay in state at the union hall. It was one of Liberty City's best-attended funerals. Caleb's widow sobbed under her black veil as she sat with the couple's four kids huddled around her. Men in both hard hats and fine tailored suits came to pay their respects.

Homicide detectives were there, too, trying to gather leads on who might have wanted Caleb dead. There were plenty of people around town who didn't mind seeing the charismatic union organizer gone from the scene. Nobody, however, was talking to detectives. The union even offered a $10,000 reward. There were no takers. No one knew it yet, but Caleb's murder set off a bitter battle over the union leadership that would lead to more bloodshed and federal indictments.

It began quickly. Six days after Caleb's death, the executive board named Cain Ballard to finish out Caleb's term, but Leroy Newson, an assistant business agent of Caleb's local, challenged the appointment, saying Ballard was just a frontman for Rubin, his boss. Newson took the union to court—and asked for protection. He said on his way home two men had tried to run him off the road. He charged that Ballard's appointment had been nullified by the membership and he had been appointed president of the local. Rubin claimed Newson had been fired as an assistant business agent.

Ballard remained president for four years. In 1976, he was shot and killed while working as a cab driver several months after refusing to run for the local's presidency again. Police called it a robbery, but Ballard's wallet was not taken.

In the days after Caleb's murder, labor department investigators began sniffing around. Rubin, his mentor, had brazenly invited them to look into Caleb's dealings at the local, but the offered hospitality backfired on Rubin. "The mob and unions have always

been connected. It was more so back then," said the retired justice department official who stepped in after Caleb's murder.

In July 1975, Rubin was indicted by a federal grand jury on 105 counts for embezzling $385,000 from the union, racketeering and income tax invasion. He was sentenced to five years and a $50,000 fine. Years later, he was convicted of plotting the murder of his wealthy in-laws.

Authorities could not link Rubin to Caleb's murder, so the investigation grew stagnant. Then came a break in the case. Dade County detectives came to learn that a Fort Lauderdale man named John Bennett, thirty-five years old, who was a member of another union, may have played a role in the Caleb murder. By this time, John Bennett was also dead, shot with a high-powered rifle and dumped on a southwest Broward County road. His wife told detectives her husband had bragged about killing Caleb, angering an accomplice who then shut him up for good.

With the assumption that Bennett was Caleb's killer, the case was officially closed in 1975. In a strange twist, the lead detective on the case had committed suicide. Some suggest that Caleb's brashness may have led to his murder. One theory is that Caleb may have made the mistake of asking Rubin too many questions or may have realized Rubin was funneling money out of the union. Rubin was later linked to the Chicago mob. Rubin's boys may have handled the problem of the "uppity nigger," the ugly words often spit out by those who hated Caleb.

But that wasn't the end of it. In a shocking development in 1982—a decade after Caleb's murder—an FBI agent suggested in federal court testimony that two South Florida labor leaders who had recently been convicted of racketeering were also involved in Caleb's murder. The agent, James Wagner of the Chicago FBI office, provided no direct evidence linking convicted Laborers' International Union officials John Giardiello and Salvatore Tricario to the murder. Instead, Wagner quoted an informant who once told him Giardiello bragged that he and Tricario "took care of a black union leader who was giving former Laborers' official Bernard Rubin problems."

Wagner mentioned the informant's recollection of his conversation with Giardiello during a hearing before U.S. District Judge James Kehoe. The FBI agent said that Giardiello and Tricario made the alleged references to the Caleb murder during a meeting in South Florida with Daniel Milano Jr., a government informant. Wagner testified that Milano told him the meeting took place between 1974 and 1976, years after the hit on Caleb.

Caleb's family and friends believe the FBI agent's story has merit. "I've heard it said that my father was killed because he was getting too big for his own britches," said Stanley Caleb, now forty-seven and a member of the union his father guided. "In my heart, I know it was union-related."

Caleb's longtime friend, T. Willard Fair, has a theory of his own. "I think he was killed by the union mafia after angering the big boys in charge." He suggested money as a motive. "If others in power at the union were getting paid, say $15, and Joe was getting $5, Joe was the kind of guy who would say, 'I want $15, too!'"

The Forgotten Man

At the Joseph Caleb Community Center in Miami's Liberty City, a mural honors the late union boss. But many who stroll in to pay bills or attend classes and events in its auditorium know little of Caleb.

Those who loved and remember Caleb fear his memory is fading into oblivion. That pains Caleb's son. "I wish the center would do more to honor my father's memory," said Stanley Caleb, foreman at a forty-story condo construction site on South Bayshore Drive. "Maybe open a small office where kids can learn about him." Joseph Caleb's younger brother, Robert, sixty-four years old, of North Miami, agrees. "Older people remember him; the younger ones don't."

Al Huston does not want Caleb ever to be forgotten. "This man did more for blacks in Miami-Dade than anyone else," he said.

The Mass Murderer Who Didn't Get Away

It was lunchtime on the afternoon of August 20, 1982, and Carl Brown, a troubled Dade County middle schoolteacher, was in a foul mood. Fifty-year-old Brown, divorced three times and ravaged by the anger that had cost him his last marriage and his job, was standing inside Bob Moore's Welding and Machine Shop, a two-story business in an enclave of scrap metal shops off North River Drive, near Miami Jai Alai. In his hands was a 12-gauge shotgun. Brown entered through the back unnoticed. He was locked and loaded.

Only minutes earlier, Brown had stormed out the front door, spewing anger over a twenty-dollar charge for the repair of a lawn mower motor and seething all the more because an employee refused to accept his traveler's check as payment. Now he was back and he was armed, and he wanted to kill someone. Everyone.

His rage boiling inside, Brown first barged into the manager's office and began firing off several rounds. One by one, he picked off employees in their cubicles. Some died sitting in their chairs. Others feigned death, hoping the madman would miss them. Others were tracked down by Brown who acted like a hunter in

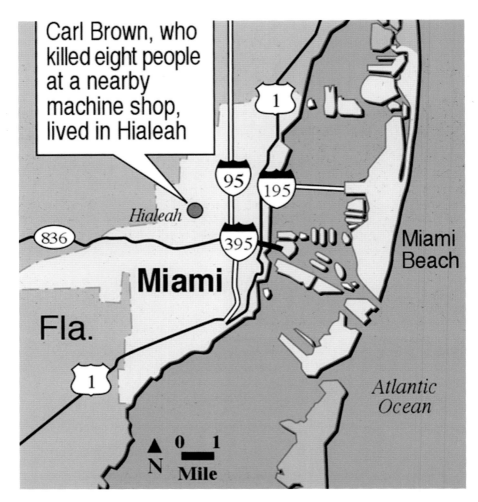

Courtesy of Dan Garrow.

The Mass Murderer Who Didn't Get Away

Carl Brown, a fifty-one-year-old former teacher turned mass murderer. This photo came from the 1979 Hialeah Jr. High School yearbook. Brown taught at the school. *Courtesy of the* Miami Herald.

the woods. He shot those who tried to run in the back, and those hiding under their desks were shot at point-blank range. Of the eleven people he targeted that day, only three survived. Brown killed owner Bob Moore's mother, Ernestine Moore, sixty-seven; his uncle, Mangum Moore, seventy-eight, the bookkeeper; Carl Lee, forty-seven, the manager; Martha Steelman, twenty-nine, a secretary; Lonie Jeffries, fifty-three, a crane operator; Juan Trespalacios, thirty-eight, a machinist; Pedro Vasques, forty-four, the shop foreman; and Nelson Barrios, forty-six, a welder.

Brown escaped on, of all things, an old, broken-down bicycle, boldly pedaling away from the bloody carnage at the machine shop with a straw hat atop his head. The blond, balding Brown looked totally harmless, except for the shotgun slung across his chest on a strap. In his pockets, he carried a fist full of live shells. He was still armed, still very dangerous to anyone who dared cross his path.

As mayhem reigned across the street, Mark Kram was just stepping out of his scrap metal shop. A hysterical Ernest Hammett, who also worked near Bob Moore's Welding and Machine Shop, ran toward him shouting, "A bunch of people just got killed at Bob's!"

Kram was no ordinary businessman; he looked too polished for his surroundings, too attractive to be in the scrap business. He was president of All Florida Scrap Metal, a company his father started four decades earlier. It had supported the family very nicely. But there was little glamour to be found dealing in scrap, where most customers were homeless people selling tin cans or discarded copper wiring to finance their next meal, or their next hit. At the time, Kram had a reputation as a ladies' man. With his thick, wavy, dark hair and bushy mustache, he was a dead ringer for Tom Selleck, the star of the hit television show *Magnum, P.I.*, which was at the height of its television fame in the early 1980s.

Kram and Hammett, a tall, skinny man who was a longtime laborer in the area, knew each other from the block. The odd couple would soon find themselves as main characters in a violent drama unfolding on what would become known as one of Miami's

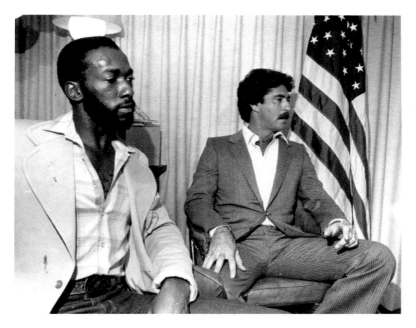

Ernest Hammett (left) and Mark Kram are seen in this September 7, 1982 file photo. Kram and Hammett chased Carl Brown five blocks in Kram's 1981 Lincoln Continental and fired a warning shot. Then, Kram recalled, he rammed into Brown with his car when he thought the cyclist was reaching for his shotgun. Brown left eight men and women dead and three others wounded at Bob Moore's Welding and Machine Service during a shooting rampage in August 1982. *Courtesy of Tim Chapman, a* Miami Herald *photographer.*

most violent days. Alarmed by what Hammett was saying, Kram ran back into his office and grabbed two guns, one for himself and one for Hammett. He then jumped into his Lincoln Continental parked outside his shop. Hammett climbed into the back seat. They went in search of a killer and became part of Miami lore.

Six blocks away, they spotted Brown, still bicycling at a leisurely pace in the industrial neighborhood near the Miami River and the Seventeen Street Bridge. As Kram pulled up alongside the teacher, who had been on psychiatric leave from work, Brown made a shoulder motion as if he were about to bring his loaded shotgun around and open fire. But he would never pull the trigger again.

Hammett, from the back seat, pointed the .38-caliber revolver out the driver's window. Kram said he grabbed the gun to steady Hammett's hand and fired what they meant to be a warning shot. "I have to tell you that both our hands were on that gun when it went off. I don't know whose finger was on the trigger," Kram later told reporters. The bullet was more than mere warning to Brown. It pierced his back and severed his aorta, but Brown showed no signs of being mortally wounded. His feet kept pedaling.

Next, Kram turned his car into a weapon, swerving the large vehicle into Brown's path. That move, it seemed, did the trick. Brown careened into a concrete utility pole and fell to the ground, where he lay motionless, his leg turned awkwardly. His bike was leaning haphazardly against the utility pole with the shotgun only a few feet away.

Then all hell broke loose. Every available police officer in Miami rushed to the scene after hearing reports of a mass murder—only to find two men armed with guns, standing near a dead man's body crumpled on the ground. The police, unsure who was the victim and who was the killer, barked orders at the two men.

For years to come, Kram would recall the chaos of those few minutes following the chase and the shooting at the machine shop. "I stood in the middle of the street waving the guns over my head so the police could see we were the good guys," Kram said.

Arriving officers immediately handcuffed Kram and Hammett and then drove them to the office of Dade State Attorney Janet Reno. She knew how a big story like this one could become explosive and take on a life of its own. A local girl, Reno was the daughter of two newspaper reporters—one from the *Miami Herald*, the other from competitor *Miami News*.

Reno, then forty-four, had been named state attorney in 1978, replacing Richard Gerstein. She was viewed as a woman in a man's job. But Reno was a stern-faced, by-the-book prosecutor who was rarely swayed by the waft of public opinion. Reno, of course, would later become the nation's top law enforcement official as U.S. attorney general under former President Clinton.

The Mass Murderer Who Didn't Get Away

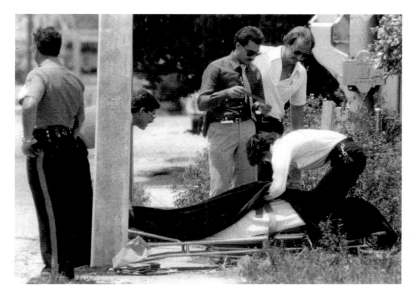

The body of Carl Brown is raised onto a gurney next to the pole where he crashed after being shot by Ernest Hammett and Mark Kram. *Courtesy of Battle Vaughan, a* Miami Herald *photographer.*

On one of Miami's bloodiest days, Reno was faced with a thorny legal dilemma: should she prosecute Kram and Hammett for the murder, even though Brown had shot and killed eight innocent people only minutes earlier in one of Florida's worst mass murders? That decision would take time to figure out. For now, attention was placed on Brown's many victims at the machine shop and in piecing together the events of a deadly morning in Miami.

At Bob's there was pandemonium as body after body—six men and two women—were found. When police arrived at the scene, bodies—some alive, others dead—were everywhere. The wounded were immediately rushed to several local hospitals. Rescue workers later learned there were too many victims to send them all to the same hospital. The dead were taken away in body bags for the ride to the Dade Medical Examiner Department— along with their killer.

What actually killed Brown? The gunshot wound or being struck by a Lincoln Continental? Not until hours later was it announced that Brown had died of a gunshot wound—from Kram's gun.

The enormity of what Brown had done alone shocked a community that had just witnessed one of the worst riots in American history. The riots in May 1980 left eighteen people dead. During the civil disturbance, some victims were pulled from their vehicles and beaten to death.

The death toll left by Brown, who is considered a spree killer, would rival those of Danny Rolling in Gainesville, Charles Manson and the Manson Family in Los Angeles and David Berkowitz—the Son of Sam—in New York. Rolling, in a three-day killing spree in 1990, raped, mutilated and butchered five University of Florida students in Gainesville. He even beheaded one victim. He was executed on October 25, 2006. Manson, who formed a cult in San Francisco during the 1960s, is serving a life sentence in prison for ordering his cult members to carry out several murders, including that of actress Sharon Tate, wife of movie director Roman Polanski, in 1970. Berkowitz sent New York City into a frenzy of fear in 1976–1977 when he murdered six people.

The intense media spotlight surrounding Kram and Hammett started almost immediately after news emerged of the murders and of the two men who slayed the madman killer. "Ernest and I were living in a fishbowl," Kram recalled in describing the massive media attention they received from newspaper, radio and television reporters from South Florida and around the world.

In some ways, the shootings fit the popular culture of the time. Vigilante killings had been glorified in the 1974 movie *Death Wish*. "Ours was one of the first vigilante killings," Kram said.

Indeed, Kram and Hammett dealt Brown a deadly dose of street justice—no arrest, no trial, no verdict. Just instant retribution for eight innocent lives lost. To some, Kram was hailed as a hero; others viewed him as a vigilante who had also killed in anger. "I never felt like a hero. I did what I thought was right at that moment, but the truth is I set out to stop Brown, not kill him," Kram told the *Miami Herald* in a 2003 interview. This interview

A Miami detective holds the 12- gauge Ithaca 37 pump shotgun with web sling and pistol grip found on the body of Carl Brown. He had used the gun to kill eight people inside a machine shop on August 20, 1982. *Courtesy of the* Miami Herald.

was the first time he had spoken publicly about the incident in two decades. "Taking a life this way is a terrible thing. Unless you've done it or served in Vietnam or something like that, you don't know what I'm talking about," Kram said.

The decision as to whether to prosecute Kram and Hammett remained in the hands of Reno and her team of prosecutors in the Dade State Attorney's Office. Most worried was Hammett, a black man who was particularly concerned about being involved in the death of a white man. "They're gonna fry me," he kept telling Kram in the months following the shootings. "Those were very scary days," Kram remembered.

Bruce Winick, a University of Miami law professor, told the *Miami Herald* in 2003 that Reno had to tackle the question of whether Kram and Hammett used reasonable or excessive force to subdue Brown and whether Brown would have killed more innocent people. "To shoot to subdue is OK; to shoot to kill is excessive force and it's murder," regardless of how many people Brown had killed, Winick said.

Within a week, Reno ruled the homicide justifiable because it was necessary to prevent imminent death or great bodily harm to others. Kram and Hammett were off the hook. But Reno stressed over and over again to the public that Kram and Hammett's actions should not be construed as "a green light for civilians to shoot down suspected criminals."

In the aftermath of the shootings, Miami changed little. It was already in the throes of a violent decade because of the cocaine wars playing out on its streets. In 1981 alone, the Dade County Medical Examiner Department recorded a staggering 621 homicides, a record high that still stands. The rest of the country got a glimpse of the gore in Miami through the popular NBC television series *Miami Vice*, which first aired in 1984.

For Bob Moore's Welding and Machine Shop, the shooting spelled the end of a longtime family business. By 1987, it was closed and liquidated. Its insurance company paid millions to relatives of those killed by Brown.

Hammett died in 1989. "He was a nice quiet guy, who like me, was always uncomfortable with what had happened that day. We didn't set out to kill anyone," said Kram.

As for Kram, he eventually found peace with what transpired that horrific day in 1982. But the shooting did mark him for life. "It's always there with me," he said. Kram, who moved his shop but remained on the same street, has spent most of his professional life in the same industrial riverfront Miami neighborhood.

In his 2003 interview, the last time he has spoken publicly about what happened, Kram's hair was short-cropped and graying, though he was still animated and youthful-looking in jeans and a red polo shirt. He sported a shiny stud in his pierced ear and had black-and-white photographs of John Lennon and the rest of the famed Beatles hanging in his office. Still fearful of retribution from those who believe he sinned by taking a life, Kram declined to be photographed or offer specific details about his life. "If you had received the letters full of venom like I did, you'd understand," Kram said. "I took the law into my own hands and some people have a big problem with that—and I understand it."

Through the years, however, many others have patted him on the back for his actions. Bob Moore, who lost his mother and uncle in the rampage, is among them. "I'm glad Mark did what he did. He should have gotten a bunch of medals," Moore said. "I would have hated to have that guy sit in prison costing taxpayers money." Moore's mother, Ernestine, sixty-seven, and his uncle, Mangum Moore, seventy-eight, were among Brown's victims. Bob Moore, now in his seventies, was in the Bahamas on business that day and has no doubt he would have been killed too.

Kram said he had kept the events of that day in his head for years, not even telling his teenage children that he killed a man so many years ago. Kram, who is now in his fifties, said his children were surprised to learn of the media avalanche that engulfed their beloved father. "I took out my scrapbook and let them read all the newspaper articles from the time," he said. "My 17-year-old daughter said, 'You did the right thing, Dad—it sounds just like you. You don't like to see people hurt.'" He

said his fourteen-year-old son was more nonplussed: "Dad, you did that?"

In the years since the incident, Kram has always wondered about Brown's state of mind that day. Brown's life had totally unraveled. The isolated, divorced father had been removed from his teaching post for his mental problems. His middle school students had given him "a weirdest teacher" award. Later, Brown's autopsy revealed he had three mysterious chemicals in his brain and may have been an undiagnosed paranoid schizophrenic. Still, Kram is painfully aware he killed a father. Brown had three children of his own. Through the years, Kram has often thought about contacting them, but then considered it inappropriate for him to approach them. After all, he had killed their dad.

Members of Brown's family were contacted by the *Miami Herald*, but they declined the chance to be interviewed. However, they did tell the newspaper in 2003 that they had no hard feelings toward Kram and that they wanted him to know that. Kram called it "a relief."

So many years later, Kram said he reacted the way he did that day because he has always felt compelled to speak up for the underdog. "But I also have a temper," he said.

Did he do the right thing in playing judge and jury? It's a question that has haunted him since the very day of the shooting. Kram said he has found his own answer in the way his life has turned out. He has been married for more than twenty-three years, has healthy children and a successful business.

A believer in the maxim, "what goes around, comes around," he said, "If what I did was wrong, I figured I would have been punished. But I've had a good life." He then adds, "It's part of Miami's history and whether I like it or not, I was part of it, too."

Christopher Wilder— Model Murderer

O n the afternoon of April 13, 1984, Christopher Wilder stopped at Vic's Getty gas station in Colebrook, New Hampshire, a tiny town tucked only a few miles away from the Canadian border. Sitting behind the wheel of a Pontiac Firebird, Wilder was alone, except for the .357 Magnum hidden in the car's glove box.

The thirty-nine-year-old Wilder was a long way from his Boynton Beach, Florida home. As he pumped $6.60 worth of gas, he struck up a conversation with the service station attendant, Wayne DeLong. His only query: which way to Canada? DeLong had no clue that Wilder was on the run, a man wanted by the FBI for attacking twelve women, nine of whom would turn up dead, during an eight-state odyssey of terror.

As Wilder and DeLong chatted, two plainclothes New Hampshire state troopers who had just finished lunch drove past the gas station. Troopers Leo Jellison and Wayne Fortier were experienced state law enforcement officers. They were well aware of Wilder's cross-country crime spree—as was the rest of the country, who kept watching as woman after woman along his trail

Courtesy of Dan Garrow.

disappeared. The troopers had been alerted that the killer might be traveling through their state.

The FBI and several state and local law enforcement agencies—from Miami to California to Texas to Upstate New York—had been trying to track down Wilder since the early days of March when he disappeared from his home in Florida. But Wilder—a well-off electrical contractor, businessman, wannabe photographer and, now, fugitive—had been elusive, always seemingly one step ahead of the law. This day appeared to be different.

The state troopers thought the car they saw at the gas station matched the description of a vehicle Wilder had stolen from one of his latest victims, a woman he killed only days earlier near Syracuse, New York. But they weren't sure, so the two troopers decided to have a closer look. Driving past the gas station a second time, they were convinced it was the same vehicle. And they were sure the tall and fit man standing next to the Firebird with his blondish, thinning hair matched the photo circulated by the FBI. Although his beard was missing, Wilder's white, shaven skin contrasted with his tan features.

"I want a word with you," Jellison blurted out as he and Fortier approached. Wilder quickly leaped into his car, reached into the glove box and pulled out the .357 Magnum. It was fully loaded.

Christopher Bernard Wilder was born near Sydney, Australia, on March 13, 1945, the oldest of four boys. His parents were Coley Wilder, an American who spent his career with the U.S. Navy, and his wife, June, a native of Australia. Like most U.S. military families, the Wilders moved all over the world, living in such places as the Philippines, Alabama, New Mexico and Virginia during the 1940s and 1950s.

Wilder had a normal childhood, other than his unusual brushes with death. As a baby, Wilder nearly died twice: the day he was born and at fourteen months when he almost drowned in a swimming pool. At age five, he nearly died again—this time when he fell into an unexplained coma while riding in the family car.

By 1960, Coley Wilder had retired from the U.S. military and the family decided to make Australia their permanent home. Chris was a teenager. In a November 1984 interview with the *Miami Herald*, Stephen Wilder described his brother to a reporter. "He was a very nervous person, very edgy, a very big, very bad nail biter. He was never calm and cool. Except when he was picking up girls." He added, "He was always able to go up and talk to girls. He could do that without any problem. It always seemed to be a line that would satisfy a girl."

Chris Wilder seemed a perfectly normal teen in the 1960s—until he had his first encounter with the law. The year was 1962. He was arrested for taking part in a gang rape of a teenage girl. The case went to a juvenile court. Wilder pleaded guilty to a lesser charge and was put on probation for one year. He also was required to go to counseling, where he received electroshock therapy.

At age twenty-three, Wilder married, though this relationship lasted only a week. Police in Sydney told the *Miami Herald* that Wilder's wife accused her husband of sexual abuse, and they had kept his name in their files. In 1969, he had another run-in with the law. This time, he was questioned for abducting a nineteen-year-old nursing student at a beach in Manly. Posing as a photographer, Wilder approached her about doing some nude modeling and got the young woman into his car. Later, he demanded the woman have sex with him, threatening her by saying he would send the nude photos to her supervisors at the hospital were she worked. The woman went to police but refused to testify against Wilder.

The use of a camera, the story of being a photographer and the pitch about turning young, pretty girls he met at malls into models would become a regular ploy Wilder used to attract his victims.

By 1970, Wilder had decided to move to the United States, choosing South Florida as a home because of its warm weather and a booming construction business. (During his high school days, he had learned carpentry.) The move would prove to be quite profitable for his ambitions as a businessman. But Wilder's personal demons followed him to Florida.

Christopher Wilder—Model Murderer

By 1980, Wilder had teamed with a partner, Zeke Kimbrell, to form a successful construction company, Sawtel Construction, and a separate electrical contracting business, all headquartered in Boynton Beach. They landed some lucrative contracts with developers. All the while, Wilder kept his criminal past a secret from just about everyone he knew.

Wilder had been arrested on three different occasions, beginning in 1971 for harassing some young women in Pompano Beach. With a camera in hand, he had asked the girls to pose nude for him. He pleaded guilty to the misdemeanor and received a fifteen-dollar fine. The portrait of Wilder as sexual predator was beginning to emerge. In 1977, he picked up a sixteen-year-old girl from Boca Raton and offered to give her a ride to a job interview. He then changed plans, driving her to a desolate area in Palm Beach County and forcing her to have sex with him in the front seat of his car. During the trial, however, a psychiatrist and psychologist interviewed Wilder separately to assess his behavior and each came to starkly different conclusions.

Dr. Edward R. Adelson of West Palm Beach concluded the following in a January 7, 1977 letter to Palm Beach Circuit Court Judge Marvin Mounts Jr.:

> *Defendant does not appear to be a mentally disordered sex offender. He is not insane and does not have a mental disorder. He has some underlying tension and anxiety and admits to having committed an offense of sexual battery. In my professional opinion, he is not dangerous to others because of a propensity for sex offenses and therefore does not satisfy the criteria of a Mentally Disordered Sex Offender as defined by* [Florida statute.]

Dr. D.G. Boozer of Miramar in Broward County could hardly agree with his colleague's opinion of Wilder. He wrote the following to the same judge in a January 2, 1977 letter:

> [Wilder] *is…a mentally disordered sex offender as per present Florida Statutes. He experiences episodes of extreme emotional upheaval during which he may not be competent nor sane. In my opinion, he is basically psychotic and in need of treatment. When left to his own resources, and under stress, he disintegrates, i.e. regresses. He presents a facade, in an interview, that covers his underlying psychotic orientation. At this time, he is not safe except in a structured environment and should be in a resident program, geared to his needs.*

The jury later set Wilder free, acquitting him of all charges. The jurors never got to hear from the doctors or review the reports on Wilder.

On the afternoon of February 26, 1984, Christopher Wilder drove from his home in Boynton Beach to downtown Miami to enjoy the two things he loved most in life: fast cars and pretty girls. The fast cars were on display at the second annual Budweiser Grand Prix. The race featured such famous drivers as Emerson Fittipaldi and A.J. Foyt.

Wilder parked his white 1978 turbo-charged Porsche Carerra near Bayfront Auditorium. A motorist would later complain that he took up two parking spaces with the sports car. The day before, Wilder himself had placed seventeenth in a preliminary race, winning $400. It was a proud moment for a man who loved to project a playboy image.

Beautiful women were everywhere on that sun-splashed afternoon in South Florida. Among them was twenty-year-old Rosario Gonzalez, a college student and part-time model. Gonzalez was hired to distribute free samples of Mejoral, an aspirin popular in the Caribbean. She was part of a sales promotional team of a dozen women who were at the race. She had her diamond engagement ring, a gray purse and wore bright red shorts and a T-shirt with Mejoral printed across the front. She was hard to miss amid the crowd of racing fans.

For Gonzalez, the gig at the race was a chance to earn some cash for her wedding in June. Gonzalez had graduated from Southridge High School in 1981 and was studying computer science at Miami-Dade Community College. She was living with her parents and an eighteen-year-old sister at the family's home near Homestead, outside Miami. In addition to modeling, she worked part-time as a sales clerk at a woman's clothing store at the Cutler Ridge Mall, one of Dade County's largest malls.

Gonzalez, who was known as Chary among her friends, was one of several women picked by a local modeling agency to work at the Grand Prix for Mejoral. The pay was $200 for working six and a half hours, from 8:30 a.m. to 3:00 p.m.

She spent the day handing out samples on the south side of Bayfront Park, near Biscayne Boulevard and Flagler Street. The last anyone saw of her was about 1:30 p.m. She had returned to the Mejoral tent outside the Pavillon Hotel, dropped off her tray of aspirin samples and left with her pocketbook to go on break or grab lunch with a man who appeared to be giving her bad news, witnesses later told police. By 2:30 p.m., with her shift nearing its end, Gonzalez had failed to return to the tent to collect her paycheck. Her co-workers searched, but found no trace of her.

Her parents, Haydee and Blas Gonzalez, had expected her to come home at 6:00 p.m. and grew worried when she had not called them by 7:00 p.m. "We knew something had happened to her," her mother said. "She would just not leave like that without calling on us or her fiancee."

The family began a frantic search for Chary. They contacted the Pavillon Hotel to see if anyone had seen their daughter. They called some area hospitals to see if their daughter had gotten into a car accident. At 1:00 a.m., with no sign of Gonzalez and no clue of her whereabouts, the family called Miami Police to report that their daughter was missing and last seen at the Miami Grand Prix. They also set off for downtown Miami to do their own search. They eventually found Gonzalez's car at 3:00 a.m. The dark gray 1980 Oldsmobile Cutlass was locked and parked near the DuPont Plaza Hotel.

On Tuesday, Miami Police went public, asking the community for help in finding Gonzalez. "The Miami Police Department is investigating it as foul play," Homicide Detective Harvey Wasserman told the *Miami Herald*. "Hopefully, we're wrong. I pray we're wrong."

Nobody knew then that Gonzalez would turn out to be the first of Wilder's victims in a crime spree that would last more than six weeks in the spring of 1984 and wind through eight states.

Police later learned that the two had met briefly, possibly at the Cutler Ridge Mall, when Wilder had shot some photos of her for a possible modeling gig. But they didn't stay in contact. To this day, police say that it is unclear how Gonzalez and Wilder crossed paths at the Miami Grand Prix. One thing is certain: Gonzalez would not live to tell her story.

Elizabeth Kenyon was a twenty-three-year-old schoolteacher who taught handicapped students and supervised cheerleaders at Coral Gables High School. Unlike Rosario Gonzalez, Kenyon and Wilder knew each other well. They had met at the 1982 Miss Florida Pageant. Despite their difference in age, the pair hit it off. Wilder even had dinner one night at the Pompano Beach home of Kenyon's parents, William and Dolores.

The Kenyons were from Lockport, New York, and wintered in South Florida. They had bought their home in Pompano Beach in 1978 so that they could live closer to their daughter, who had gone to the University of Miami.

Wilder was so taken by Kenyon that within weeks of dating he asked her to marry him. She said no, saying he was more like a big brother to her than a potential lover. The pair remained friends— at least until the evening of March 5, 1984. Kenyon would be Wilder's second murder victim.

But it would be a North Miami private eye by the name of Kenneth Whittaker Jr. who would first bring Wilder to the attention of Miami and Metro Dade Police investigators. He was the first to link the disappearance of Kenyon and Gonzalez.

Whittaker, then twenty-eight years old, had been hired by the Kenyon family to find their missing daughter. She had not been

Christopher Wilder—Model Murderer

Elizabeth (Beth) Kenyon, part-time model and schoolteacher, is one of two Miami victims believed to have been killed by Christopher Wilder in 1984. Kenyon's body has not been found. *Courtesy of the* Miami Herald.

considered a homicide victim by cops. The case began for Whittaker three days after Kenyon disappeared after driving away from the school in Coral Gables. Picking up the trail was initially easy for Whittaker, who had attended law school but later decided to join his father, a former Miami FBI agent, in the private eye business.

Kenyon had apparently stayed at the school until 3:00 p.m., working out with the cheerleaders. She then left with a duffle bag containing her workout clothes and a curling iron. Whittaker found out from Coral Gables police officer Mitch Fry, assigned to the high school area, that Kenyon regularly filled the tank of her convertible at a Shell station on South Dixie Highway, near the school. It was a slim lead, but it was worth a shot.

An attendant at the gas station told Whittaker that Kenyon had been there on the Monday she disappeared. He remembered that a man had followed her into the station. Whittaker showed the attendant several pictures of Kenyon with the different men she dated. When the attendant came to a picture of Kenyon and Wilder together, he stopped. That's the man, he told Whittaker. That attendant would be the only eyewitness to provide a firm lead in the case.

The attendant told Whittaker that Wilder had pulled in behind Kenyon in his El Dorado, jumped out of his car and gone over to the attendant, pulling out a twenty-dollar bill and telling him to put ten dollars worth of gas in Kenyon's car. Then Wilder went to talk with Kenyon. Whittaker said the attendant overheard pieces of the conversation. "Beth asked the man, 'Am I dressed well enough?'" Whittaker said. "'They'll provide you with the clothes,' Wilder responded. 'Who's going to take my picture?' she asked."

Whittaker said the attendant then went to clean Kenyon's window and she told him, "'Don't clean it, I'm already late for the airport.'" Whittaker said, "I think Wilder told her they were meeting someone, some photographer, at the airport." Whittaker felt that Wilder was very much aware that the attendant saw him with Kenyon and overheard the conversation.

Whittaker tracked down Kenyon's car. It was found at Miami International Airport. "We went to every airline worker at the

airport and showed them pictures of Kenyon. Nobody recognized her." Whittaker believes they didn't go into the airport.

After only two days on the case, Whittaker had determined Wilder was one of the last people to see Kenyon. So Whittaker and Kenyon's mother phoned Wilder to ask him if he'd seen Elizabeth. "He said no and wanted to cut the conversation short." Whittaker thought Wilder's reaction was too nonchalant for a man who had an emotional attachment to the young woman. Here was a man who had dated Elizabeth Kenyon for about a year and had told her girlfriends that he was in love with Kenyon. "He had treated her like a princess," Whittaker said. "He had taken her to fancy restaurants and was always a perfect gentleman. When Wilder tried to end the conversation, I told him it wasn't that easy, that we had an eyewitness who had seen him with Beth." But Wilder was adamant that he was not with Kenyon on the day she disappeared. He responded that he was at his home in Boynton Beach.

Whittaker said he felt "something was out of sync." Wilder agreed to meet Whittaker the next day, but he didn't show. Whittaker finally tracked him down on Monday, a week after Kenyon's disappearance, at his Boynton Beach office. Whittaker brought an eyewitness statement from the attendant. "He told me he had an alibi for that day; that he had been at several work sites and then back at the office by 3:30 p.m.," stated Whittaker. Wilder then called an employee into his office who verified Wilder's alibi. The employee later would admit to police that he had been lying for Wilder—he hadn't been in the office that day.

Whittaker described Wilder as a "man's man, a real likeable guy." Wilder seemed prepared for his interview with Whittaker. "He was always trying to control the conversation and seemed well-rehearsed in his answers. He had covered his tracks well. When I asked him to come to a line-up, he said, 'By all means. You probably know about my background, but I want to clear my name.'"

Wilder agreed to talk to a police investigator the following day to set up a date for a line-up. Whittaker invited both Miami and Metro Police to attend. But Wilder skipped town. "I had a feeling he'd skip, but by then the police were in on it and they couldn't put

an illegal surveillance on him for fear that it could later hurt their case in court," Whittaker stated.

Police later surmised that the prospect of Whittaker's face-to-face confrontation with Wilder probably spooked the suspected killer into fleeing Florida and set him on the cross-country terror tour. After Kenyon disappeared, it was gut instinct that told Whittaker that Wilder was his man. "It was just so strange. He [Wilder] didn't seem worried about her safety at all. He just said he'd call some people and check if they had seen her."

On the night of March 15, 1984, a worried Wilder arrived in Daytona Beach in his 1973 Chrysler New Yorker and checked into a Howard Johnson motel. He was glad to be out of South Florida, where he was convinced that Whittaker and the police were trying to build a case against him for the disappearances of Gonzalez and Kenyon.

Daytona Beach was ideal for Wilder. It was spring break and the city and its beaches were crawling with young, beautiful women. With his camera slung around his neck, Wilder wasted little time in finding his next victim. Colleen Orsborn, a petite fifteen-year-old girl with light brown hair and hazel eyes, had left her home that morning around 8:00 a.m. and was never seen again. The only thing missing from her room was a two-piece bathing suit. Her body has not been found to this day, though the family received an anonymous letter from New Hampshire from someone who purportedly knows where Orsborn is buried.

On March 18, 1984, Wilder struck again. This time it was in nearby Cocoa Beach, where a shopper later told police she saw a man fitting Wilder's description in the company of a young woman inside the Merritt Square Mall near Cape Canaveral. The girl was twenty-one-year-old Theresa Wait Ferguson of Satellite Beach. Ferguson had left home that day and parked in front of the JC Penney store at the mall. Inside, she hopped from store to store, buying a blouse and a pair of shoes. She paid little attention to the man who had been keeping an eye on her until he approached her.

Police do not know what Wilder told Ferguson, but they later learned he had to call a tow truck after his Chrysler got stuck in the sand in a rural area known as Canaveral Groves. Ferguson's body was found several days later in a creek near Haines City. She was dressed in a pair of Calvin Klein jeans, a reddish tank top and the blouse she had bought at the mall. A gold chain was around her neck. Her shoes and purse were missing. The medical examiner ruled the cause of death as strangulation.

That same night, Wilder drove to Tallahassee, where he would find his next victim, Linda Erica Grober. On the afternoon of March 20, 1984, Grober, a nineteen-year-old freshman at Florida State University, was just another shopper at Governor's Square Mall. She had skipped classes to spend that rainy day at the mall. Grober stood five feet, four inches tall and was a blonde with blue eyes, the kind of girl Wilder couldn't resist.

Dressed in a suit, Wilder struck up a conversation with her and tried to convince her to model for him at his local studio. He gave her twenty dollars and told her to wait for him to check if the studio was open. He returned with bad news; the studio was closed. Grober then said she needed to go home. Wilder offered to walk her out to her car, which happened to be parked right next to his. It was no coincidence. Wilder had been stalking Grober for about a week. He knew her every move.

In the parking lot, Wilder punched Grober so hard that she buckled over. He then shoved her in the car and drove off. It was the middle of the afternoon. Grober seemed destined to become another Wilder victim.

But somehow she escaped, detailing to police how Wilder tortured, raped and sodomized her inside a sleazy motel room in Bainbridge, Georgia, some two hundred miles from where he first found her at the mall. She identified Wilder as the man who abducted her from the mall and told authorities in Georgia that he had blindfolded her, gagged and bound her with duct tape and rope and then tossed her into the trunk of his car. She told them he kept playing the same song by the British duo Eurythmics, "Here Comes the Rain Again," over and over again in the car.

Later that night, Wilder got a room at the Glen Oaks Motel in Bainbridge. He stuffed Grober into a sleeping bag and dragged her into the room tucked in the back of the motel. Once inside, Wilder attached two electrical cords to her, plugged the other end into an electrical socket and rotated a dimmer switch with his hand to shock her. He kept jolting her with electricity. He also used Super Glue to keep her eyelids shut, though she later told police she could still peek through one eye.

She ended up in a fight with Wilder, with her kicking, hitting and biting him, and he doing the same to her. In one instance, she dashed into the bathroom, locked the door and began screaming. A nervous Wilder bolted from the motel room and took off back to Tallahassee.

Grober, meanwhile, waited about a half-hour, walked out of the bathroom, wrapped herself in a bed sheet and told the clerk at the front desk to call the police. Authorities, for the first time, had an eyewitness account of Wilder.

By the evening of March 23, 1984, Wilder had made his way from Tallahassee to Texas in search of his next victim. He found one in Terry Diane Walden, a twenty-three-year-old nursing student and mother of two. Walden disappeared after dropping her youngest daughter at a day care center in Beaumont, Texas. Her body was found three days later. She had been stabbed, with her hands and feet bound, and tossed into a canal. Although Wilder's Chrysler New Yorker was found, the victim's car, a Mercury Cougar, was missing.

On March 25, 1984, only two days after killing Walden, Wilder abducted Suzanne Logan, twenty years old, from a mall in Oklahoma City. Her body was found the next day in Milford Lake, Kansas. Wilder had beaten and stabbed her and bound her with duct tape and nylon cord.

On March 29, 1984, Sheryl Bonaventura, nineteen years old, was reported missing from a Grand Junction, Colorado mall. The FBI later learned that Wilder, using the name of his business associate in South Florida, L.K. Kimbrell, had taken the teen

An eerie photo of Christopher Wilder sitting in the audience of a *Seventeen* magazine pageant in Las Vegas. He later met with one of the contestants, Michelle Korfman. Her dead body was found on May 11, 1984, in California. *Courtesy of the Miami Herald.*

with him. Her nude body turned up along a rural road north of Kanab, Utah. She had been shot and stabbed to death, and police reported finding pieces of duct tape near her body.

Wilder arrived in Las Vegas on March 31, 1984, where the following day he attended a *Seventeen* magazine pageant, another ideal setting to find his next victim. Among the girls in the fashion show was seventeen-year-old Michelle Korfman, a Boulder City high school senior who had dreams of one day becoming a model. Her body was found six weeks later in a remote part of the San Gabriel Mountains about twenty miles north of downtown Los Angeles. It was so badly decomposed that she could only be identified through dental x-rays.

By April 3, 1984, Wilder knew authorities were on his trail. He was right. Two days later, the FBI put Wilder on their "Ten

Most Wanted" list, describing him as "an extremely aggressive individual" and a "badly wanted fugitive."

But Wilder's terror odyssey was not over. And Tina Marie Risico, a sixteen-year-old from Torrance, California, seemed like another victim for Wilder to add to his list. He met Risico at a local mall in Torrance and persuaded her she would be perfect as the model for a billboard ad he had signed up to do. He gave her $100. She went along and became an unwilling accomplice in Wilder's sex-crazed race across America.

By this time, Wilder had traveled from Florida to California and was heading to the Mexican border. But he suddenly changed his mind and began traveling east.

Risico became Wilder's personal slave. And she obeyed his every command, even when it meant committing a crime herself. Police later said that Wilder had brainwashed the young teen. On April 10, the pair arrived in Gary, Indiana, and came across a young girl looking for a summer job at the Westlake Mall. Her name was Dawnette Sue Wilt. Posing as a store employee, Risico chatted with Wilt, telling her she should meet her manager. That's when Wilder appeared and flattered Wilt, telling her she could also be a model. They convinced Wilt to go outside to the parking lot under the guise of signing some modeling release forms. When they got out to the car, Wilder flashed a gun in Wilt's face and forced her into the car. After binding her hands and feet in duct tape, Wilder got behind the wheel and told Risico to follow him in Wilt's car. Risico followed his instructions. Wilt's car was abandoned before they left Indiana.

The trio ended up in western New York state. Ron Spike, chief deputy of the Yates County Sheriff's Department in Penn Yan, New York, would later tell a *Miami News* reporter that Wilder tried brainwashing Wilt, too. "He insisted that the girls address him as 'sir' or 'dear,'" he said. "He would repeat certain phrases over and over, such as 'Who do you obey?' to which they would have to reply, 'You dear,' or 'You sir.' He would say things like, 'I've killed other women and I'll kill you too if you don't obey,' to which they would answer, again, 'Yes dear,' or 'Yes sir.' He also said, 'I'll

kill you. Spell kill,' and they would have to answer 'K-I-L-L.' He would do that over and over and over again."

On the night of April 11, Wilder, with his two hostages in tow, rented a motel room south of Rochester. The following morning, they drove nearly fifty miles to a wooded area near Penn Yan, New York. It seemed like the end of the line for Wilt. Blindfolded with duct tape, Wilder shoved Wilt into a wooded area off a dirt road and began stabbing her in the chest and back. Thinking she was dead, Wilder walked back to his car and left.

Somehow, Wilt stumbled to the road. She flagged down a passing motorist, who took her to a local hospital. She had survived Wilder's rage. When police spoke to her, she described the same man the FBI and other law enforcement agencies had sought for several weeks. It seemed as if time was running out for Wilder.

On April 12, 1984, Wilder and Risico were driving back to Rochester when they decided to pull into Eastview Mall near Victor, New York. At about the same time, Mary Beth Dodge, a thirty-three-year-old Sunday schoolteacher, arrived at the mall, too, in her 1982 Pontiac Firebird. Before she set foot in the mall, Wilder flashed a gun in her face and forced her into his car. Risico was told to drive the Firebird. A few miles away at a remote gravel pit, Wilder fired a bullet into Dodge's back, killing her as she lay face down in the dirt.

Risico and Wilder returned to the mall area, parked their Cougar and took off in Dodge's Firebird. The next stop would be Logan International Airport in Boston. Here Risico would be freed by her captor.

It was around 9:00 p.m. when Wilder entered the airport, stepped up to the ticket counter at Delta Air Lines and purchased a one-way ticket to Los Angeles. He then handed several $100 bills and the plane ticket to Risico. A few months later in an interview with the *Los Angeles Times*, Risico said she believed her life was spared because Wilder fell in love with her. "He told me to kiss him on the cheek. He said, 'All you gotta do, kid, is write a book,'" she told the newspaper. "It was heartbreaking. It was so sentimental."

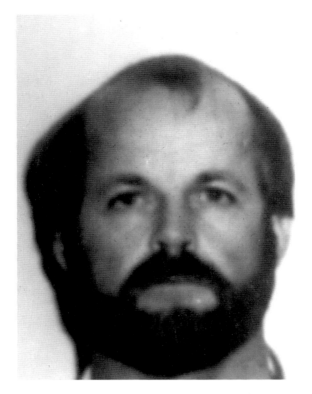

A mug shot of Christopher Bernard Wilder, who abducted twelve women, killing nine, during a six-week crime spree that crisscrossed the nation in 1984. Wanted by the FBI, Wilder was cornered in Colebrook, New Hampshire, on April 13, 1984. He died from two bullets fired from his own gun. *Courtesy of the* Miami Herald.

The following day, April 13, 1984, Wilder climbed into the stolen Pontiac Firebird. He was bound for Canada and just needed to get through New Hampshire to cross the border.

With Wilder's hands on the .357 Magnum, Trooper Jellison acted fast. Jellison, six feet, two inches and 250 pounds, leapt onto the smaller Wilder's back, wrapping him in a bearhug as both men lay sprawled on the front seat of the Firebird. Then came the sound of two bullets in rapid succession.

The first bullet went right through Wilder's chest, exited his back, went through Jellison's rib and came to rest on top of his liver. The second bullet, too, ripped through Wilder's chest. Local pathologist Dr. Robert Christie would later conclude that the two bullets fired from Wilder's gun followed the same path, maybe a centimeter apart, through his body before striking his heart. "The heart was disintegrated," he wrote. The cause of death was listed as "cardiac obliteration."

Only hours before the shooting, clear across the other side of the country, sixteen-year-old Tina Marie Risico had arrived safely at Los Angeles International Airport. She would later tell the *Los Angeles Times* that she was in shock. "I couldn't cry. My mind was just so…blank. I thought, 'I can't cry. I don't care. I'll just go shopping.'"

That's exactly what she did, dropping by a shop in Hermosa Beach and purchasing $100 in lingerie. She then worked up the courage to walk into the Torrance Police Department in Southern California to tell authorities a story—a story about a man named Wilder.

Epilogue

On April 9, 1985, the *Miami News* published the following letter from Agnes Duchan, mother of Suzanne Logan, one of Christopher Wilder's murder victims.

> *Why was Christopher Wilder allowed to walk around free?*
>
> *On March 25, 1984, Suzanne Logan, a 20-year-old newlywed, was believed to have been abducted in Oklahoma City by Christopher Wilder, who drove her to Kansas, tortured her and dumped her battered body by a lake. She was about to be buried under the name of Jane Doe when her identity was discovered. Her mother, Agnes Duchan of Tulsa, wrote a letter to the Miami News on the anniversary of her daughter's death, excerpted here.*

The body of spree killer Christopher Wilder arrives in West Palm Beach in April 1984. *Courtesy of the* Miami Herald.

"It has been one year since my beautiful daughter Suzanne was raped, beaten and stabbed to death by Christopher Wilder. A year of intense pain, desolation and despair. No one knows the trauma of losing a child this way unless they have experienced it.

"Suzanne was intelligent, sweet and kind to everyone and a wonderful daughter with so much to live for. She had been married nine months and I looked forward so much to holding her baby one day.

"All our dreams were shattered on March 26, 1984, by a man who should never have been walking amongst normal people, had everyone concerned done their duty.

"When I look at the pictures of all these beautiful girls he tortured and killed and the so-called 'lucky ones' who

escaped to live with the horrible memories, I think of all the families and loved ones who are suffering like we are, and wondering why.

"Why was Christopher Wilder allowed to walk around free? From the accounts I have read, he had violent sexual problems since he was a teenager in Australia. In 1977, he was charged with sexual battery in Palm Beach County. At that time, two psychiatrists…examined him. (One) said he was psychotic and should be institutionalized. (The other) said he was not dangerous. The jury was not shown the reports, and found Wilder not guilty. Why?

"In 1980, in West Palm Beach, Wilder pleaded guilty to another sexual battery case involving a 17-year-old girl to whom he gave pizza laced with LSD. Yet he was only given five years probation. Why?

"In 1982, he broke his probation by going to Australia. While there, he was charged with sexually assaulting two teenagers and released on ($350,000) bail. On returning to America, he was only put on a $1,000 bond for parole violation. Why?

"What is wrong with the criminal justice system in this country?

"In 1984, after Beth Kenyon disappeared, the Kenyon family hired a private detective…who gathered enough evidence against Wilder to at least apprehend him. Yet Miami police…knowing Wilder's background, didn't even question him after being given the evidence…Why?

"Metro police (were) also told about Wilder, but never questioned him either, as (they, like Miami police) also had to build (their) own case. Why?

"They didn't even contact Wilder's probation officer, Richard Irwin, who could have had Wilder arrested for breaking his probation (for) attending the Miami Grand Prix. Why?

"My daughter's body lay in a morgue in Kansas for 10 days as no one could identify her. Al Buskey,

chief investigator for Geary County, Kansas, Sheriff's Department (who are really on the ball) put her description on the NCIC system nationwide. Meanwhile...the Oklahoma City Police Missing Persons Bureau had Suzanne's description and no one in that department bothered to check the NCIC and compare descriptions. Why? They didn't even search for her car. Her husband and I found it in the Penn Square Mall parking lot— three miles away. It had been there five days, yet no one bothered to ticket it. Why?

"In frustration, we hired a private detective, Bill Wilson, and in seven hours he found where Suzanne's body was and tied the whole case together—something the police could not do in 10 days. Why?

"I have heard people complain about law enforcement agencies' indifference and incompetence, but never realized it till I experienced it myself. Should we increase law enforcement agents' salaries and maybe instill a better attitude and attract applicants with a higher degree of intelligence? Does anyone care?

"Most of the victims' families sued Wilder's estate, which was reportedly worth $1.9 million at the time of his death. A few months ago, we were informed that his estate was worth about $900,000. Recently, we were told he only had about $500,000 left and the red tape would go on so long that this would probably be used up in legal expenses and lawyers' fees.

"So the victims' families get nothing. Not that this money really matters now. It will never bring our children back. What a strange system we live with, where everyone involved in these disasters gain, except the victims who lose in every way. And no one seems to care."

Andrew Cunanan and Gianni Versace Meet in South Beach— for Murder

O n the afternoon of July 7, 1997, a young man wearing a baseball cap slanted over his unshaven face wandered into a pawnshop on Miami Beach. He was strapped for cash. On the other side of the counter was Vivian Oliva, a no-nonsense Cuban-born mother of two who toiled at Cash on the Beach, her brother's shop at Seventy-first and Collins. She knew the art of negotiating with those needing a quick buck.

"I'll give you $190 for it," Oliva told the man after he presented the 22-carat gold coin. "Why so little?" he whined, then quickly agreed to the exchange.

The man handed over his passport to prove his identity and told Oliva he was in town as a tourist staying at the nearby Normandy Plaza Hotel. He walked out, cash in hand, disappearing into the thumping neon of Miami Beach.

What Oliva and the rest of South Florida didn't know on that summer day was that the man in the pawnshop was Andrew Cunanan, a twenty-seven-year-old gay gigolo plotting the last

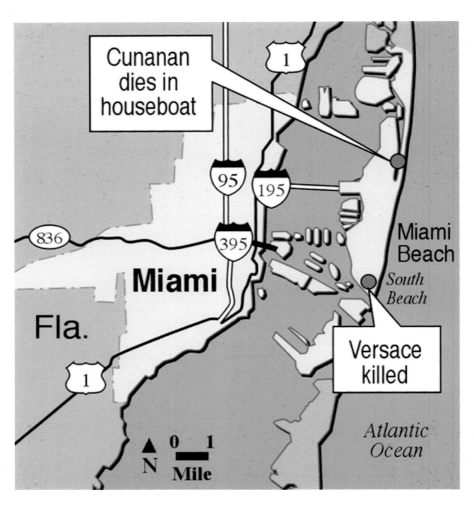

Courtesy of Dan Garrow.

I Pledgor/Seller, agree to all terms and conditions on the front and back and acknowledge receipt of a copy of this document.
Under penalty of perjury, I have read the foregoing document, and the facts stated in it are true.

X _Andrew P. Cunanan_

NOTICE: See reverse side

A copy of the pawnshop slip signed by Andrew Cunanan only days before he murdered fashion designer Gianni Versace in front of his Miami Beach mansion. *Courtesy of the* Miami Herald.

chapter of a murderous cross-country spree. He had been in town for weeks, stalking his final victim—renowned fashion designer Gianni Versace, South Beach's most famous resident. The high-profile murder would bring a mob of international media attention to Miami Beach and forever link the city to one of America's most notorious crimes.

The youngest of four children of an upper-middle-class Filipino stockbroker and his Italian-American wife, Andrew Phillip Cunanan was born on August 31, 1969, and grew up in a well-to-do San Diego suburb. The family had moved to the area in 1972 after Cunanan's father, Modesto "Pete" Cunanan, a native of the Philippines, retired after nineteen years in the U.S. Navy. He found work as a stockbroker and achieved a certain level of success. His mother, Mary Ann, was a homemaker, who doted on Andrew and his big brother, Christopher, and two older sisters, Eleina and Regina.

Cunanan's parents, at their youngest son's insistence, made sacrifices to send him to The Bishop's School, a preppy and

prestigious private school in La Jolla, California. The teen became well known for two traits, friends later told the FBI. He was flamboyantly gay and a pathological liar, endlessly manicuring and manufacturing his background.

"He would whistle at the water polo team," Stacy Lopez, a twenty-eight-year-old former classmate, told the *Chicago Tribune* in 1997. "He could pull it off because he was funny and so over the top. You couldn't help but like him."

So outlandish was Cunanan that he appeared at his high school prom decked out in a fire red jumpsuit with an oversize zipper—a gift from his date, an older man and Cunanan's latest sugar daddy. His graduating class of 1987 voted him "Least Likely To Be Forgotten"—a description that would eventually come true.

After graduation, he went on to college, studying locally at the beautiful oceanside campus of the University of California at San Diego. When not in school, he used his exotic good looks to attract older, wealthy gay men who allowed him a life of leisure and partying, complete with drugs and affairs. All seemed grand for the party boy, but Cunanan would soon endure a crisis in his family.

It all began when Modesto Cunanan left the family in 1988 and moved to his native Philippines to avoid charges of embezzling $106,000 in stock funds, according to divorce papers filed in San Diego Superior Court by Mary Ann Cunanan. Mary Ann would eventually move to Illinois and live on welfare in order to survive.

The younger Cunanan took the news hard and traveled to the Philippines in December 1988 to visit his father. But he quickly returned to the United States because of the squalid conditions. Cunanan would spend the next several years dropping in and out of college, wandering much of Southern California unsure of what road he should travel in life.

Things started looking up in 1995 when Cunanan met a wealthy sugar daddy. His name was Norman Blachford, one of a long line of rich men Cunanan used to finance the upscale life he coveted but could not afford. Blachford, who had homes in Scottsdale, Arizona, and La Jolla, California, gave Cunanan a

Andrew Cunanan and Gianni Versace Meet in South Beach

A photo of Andrew Cunanan in high school in San Diego, California, in 1987.
Courtesy of the Miami Herald.

$2,500-a-month allowance to keep him around and happy. Friends say Blachford gave Cunanan the life he felt he was entitled to, the life he had lied to his friends about. He wore designer clothes, ate at the best restaurants with his younger gay friends and tipped generously—just to assure a good table the next time around.

Blachford had definitely fallen under Cunanan's spell. Cunanan's game plan to land and keep a sugar daddy had worked again. He had always followed the same strategy: find out everything he could about his target. He would learn of their careers, interests, hobbies and go to the public library and check out books on the subjects. That way, he would come across as a presentable boy toy who could be taken to fancy dinners and social events.

In addition to money, Blachford gave Cunanan a new, dark green Infiniti J30. It was not enough for Cunanan. He wanted a Mercedes-Benz SL600 and was convinced Blachford would buy it for him, he told friends. The demand for money would eventually wear on Blachford. By late 1996, Cunanan was an aging gay gigolo who was about to lose his meal ticket.

During this period, Cunanan would often fly to San Francisco, telling Blachford he had an ex-wife in the city. Friends suspected he was selling drugs, crystal methamphetamine, Xanax and steroids. All along, Blachford had believed Andrew's last name was DeSilva, according to his interview with the FBI.

It was in San Francisco that Cunanan met David Madson at a bar in the gay Castro District. Madson was the portrait of the perfect preppy man. He was short and slightly built and had deep blue eyes and wispy blond hair. The young architect was in the city on a job-related trip from Minneapolis and was staying with friends. That night, Cunanan, who this time gave his real name, took Madson back to his hotel and the two embarked on a sexual relationship where Cunanan played a dominant role, he told friends. The two men gave each other the impression of being professional, young gay men, either well employed or with money.

When Madson returned to Minneapolis, the two continued a long-distance relationship, sending each other gifts—expensive

ones from Cunanan—postcards and love letters. They saw each other as often as they could. Madson had no idea about Blachford. At first, he didn't question why Cunanan only had voice mail and a pager and didn't seem to have a permanent residence, simply living wherever his mysterious business sent him.

Cunanan, said friends, began falling for Madson, seeing him as his true love, his future. He was the only man he loved who loved him back with no money exchanged. Their long-distance relationship continued for most of 1996, with Madson meeting some of Cunanan's California friends. But Madson began to pick up bits and pieces about Cunanan's character. That he did drugs, possibly sold them. That he was a compulsive liar, a shifty character. He seemed desperate to impress. Madson got cold feet and began to hint in his letters to Cunanan that they should just be friends. Cunanan was devastated, beginning to feel that he was about lose the love of his life. He had to do something.

At about the same time, Cunanan's best friend, Jeff Trail, or JT, was out of the navy and was making plans to become a California Highway Patrol officer. He went to Sacramento to try out, but eventually decided being a gay CHiP would be a mistake. He moved in with his sister in the Bay area and met a bartender—a new boyfriend. During this time, Cunanan introduced Trail to "the man who I want to marry"—Madson.

It is unclear if Trail and Cunanan had any kind of intimate relationship; for all intents and purposes they were just friends. Trail was a Midwestern boy who had been stationed in San Diego for the U.S. Navy. When he met the urbane sophisticate Cunanan, he was introduced to the gay high life in San Diego.

By early 1997, Cunanan had ended his relationship with Blachford, who had refused to give him the coveted Mercedes. As a sort of divorce settlement, Blachford gave him $10,000 and the Infiniti, which Cunanan sold for $20,000. Cunanan would soon pursue his real passion—Madson.

Meanwhile, Trail, who had broken up with his boyfriend in San Francisco, landed a job with a propane company. He was to start work in, of all cities, Minneapolis, where Madson also lived.

Cunanan had blown most of Blachford's money on drugs, restaurants, bars and clothes. In the months to come, both Madson and Trail began giving Cunanan the bum's rush. Madson had begun dating another man from Washington, D.C. Trail was into his new career and a new relationship. Cunanan had been forgotten. In desperate efforts to keep his friends, Cunanan visited Minnesota twice—both disastrous occasions as he was often high and making a public spectacle.

In March 1997 Cunanan pushed his company on Madson once again, after having just given him an $11,000 watch. He called and said he was coming to town again to visit Trail, who he planned to stay with. Madson didn't know Trail was only letting him stay for one night. Friends said Madson and Trail had little in common except Cunanan, who they both had outgrown. They had compared notes about Cunanan, with Trail filling in the blanks for Madson and opening his eyes to the truth about the mysterious gay man from San Diego—he was bad news all around. But it was too late. Cunanan was coming to town.

During this visit, Cunanan came to suspect Trail had turned Madson, "the man he wanted to marry," against him. And that's when he snapped. During a heated fight in Madson's apartment in a converted warehouse in Minneapolis, he crushed Trail's head with a claw hammer. Authorities later found the body wrapped inside an oriental rug. Days later, authorities also found Madson's body in some tall grass in an open field near a lake about forty miles north of Minneapolis. He had apparently witnessed Trail's murder and paid for it with his life.

It's unclear why Cunanan became so violent. Criminologists who studied his rampage concluded he was a spree killer—someone driven to kill by an emotional blow, usually in a sudden spurt of violence. His perceived rejection by Madson and Trail, they say, likely triggered the killings.

With two victims dead, Cunanan was now on the run in Madson's Jeep—killing for convenience and with ease. His next stop would be Chicago where he found his third victim, seventy-one-year-old Lee Miglin, a wealthy Chicago developer. Police in

Chicago said Miglin was found stabbed to death on May 3, 1997, beneath a car in the garage of his posh brownstone townhouse.

A report later released by authorities provided a gruesome description of Miglin's murder. He was nearly decapitated and had forty-nine wounds, including nineteen blows to the head and face. Every rib in his body was broken. His head was wrapped in masking tape, and his throat had been slashed. Miglin's 1994 Lexus was missing.

The police connected Cunanan to Miglin's murder when a cop writing tickets in the area around Miglin's home spotted a Jeep Cherokee with Minnesota license plates. The car had several parking tickets on the windshield, prompting the officer to look up the owner. She traced it back to Madson's address in Minneapolis.

Cunanan had apparently tortured Miglin and taken off with his Lexus and the gold coin he would later pawn in Miami Beach. He snatched $6,000 in cash, a leather jacket, two suits and a dress shirt. He also made himself at home—police found a half-eaten ham sandwich in the kitchen.

It's unclear why Cunanan traveled to Chicago, but authorities later reported that Miglin and Cunanan did not know each other. Miglin just happened to be the victim of a random robbery. Cunanan had chosen the neighborhood because "that's where people have money," Police Lieutenant Nick Neas told the media.

Cunanan's next stop was New Jersey. His fourth victim was William Reese, a forty-five-year-old South Jersey cemetery caretaker. Reese's body was found on the evening of May 9, 1997, in the caretaker's office at Finn's Point National Cemetery. The body had a gunshot wound to the head. Police found the body after Reese's wife, Alice, called police when her husband did not come home from work. She had driven to the cemetery herself and noted that his 1995 Chevy pickup truck was missing.

That evening, Salem County, New Jersey Prosecutor Ronald Epstein told reporters that the shooting had likely happened between 2:00 p.m. and 6:00 p.m. and that Cunanan was the prime suspect because they had found Miglin's car at the cemetery. Again, no connection between Reese and Cunanan was

ANDREW PHILLIP CUNANAN

The many faces of Andrew Cunanan, who in May 1997 turned up on the FBI's "Ten Most Wanted" list. *Courtesy of the* Miami Herald.

established. He had merely killed another random victim and was on the run. Where he was headed next was anyone's guess. Some thought he would return to New York where he could get lost in the city's large gay community.

New Jersey State Police and the FBI immediately issued an all-points bulletin for Cunanan, now suspected in the murders of four people in three states. That weekend, the story of Cunanan's cross-country murder odyssey was featured on the Fox television show, *America's Most Wanted*. Cunanan was on his way to becoming a household name.

Cunanan did not head to New York, but instead went to Miami Beach, where he would find his fifth and final victim, fashion designer Gianni Versace. Cunanan rolled into Miami Beach

sometime in mid-May and hardly went into hiding. He frequented local gay bars, auditioned to appear in gay porn and hustled for cash. He became a regular at a Miami Subs near the thirty-six-dollar-a-night Normandy Plaza Hotel at Sixty-ninth and Collins. He visited the local Miami Beach library, checking out lofty books about architecture and literature. He told people his name was Andrew DeSilva. That would become his alias.

By the day of the murder, Cunanan had skipped out on his hotel and was living out of the stolen pickup truck, which he kept at a city parking lot just two blocks from Casa Casuarina, Versace's palatial beachfront home at 1116 Ocean Drive. Police would later learn he had stayed in the low-rent room for nearly a month, from May 12 to July 11. The room was littered with highbrow art and history books and several *New Yorker* magazines. Among the books was one by Thomas Cahill, *How the Irish Saved Civilization*. There were also histories of modern art and art deco, as well as a book on the life of English philosopher, statesman and scientist, Sir Francis Bacon.

Versace, fifty years old, had just returned to Miami Beach from Europe—and Cunanan had been waiting for him, police later determined. On the day of the murder, July 15, 1997, Versace awoke early. Dressed in gray sweat pants and a black T-shirt, he walked two blocks south to the well-known News Café. He ordered a cup of coffee and purchased five magazines: *Newsweek, Entertainment Weekly, People, New Yorker* and American *Vogue*.

Versace was one of South Beach's so-called "beautiful people." His mansion home on Ocean Drive symbolized South Beach's emergence as one of the world's trendiest locales, a place to eye such celebrities as Madonna and Sylvester Stallone on any given day, a favorite of the fashion industry and a must-see stop for tourists. This image would soon be tarnished by a kid from California with a wounded ego and a craving for attention.

It was a sunny morning, about half past eight, and few people were out and about on Ocean Drive. Versace strolled back home, greeting a couple of people who recognized him. As he reached

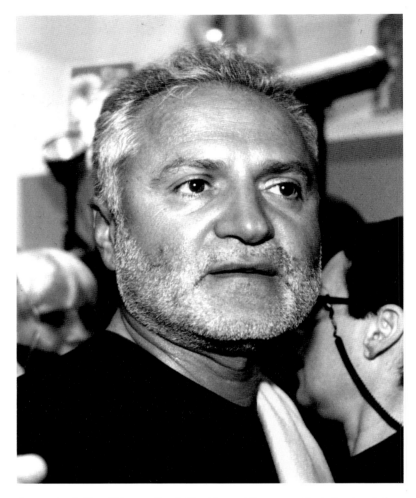

A portrait of Gianni Versace, South Beach's most famous resident. *Courtesy of the* Miami Herald.

the foot of the stone steps of his gated home, an Italian woman crossed his path. They smiled at each other.

Cunanan, lurking in a park across the street, dashed toward Versace, who was fidgeting with the keys to his ten-foot, ornate, wrought-iron gate. Cunanan ran up close behind him, right arm outstretched. He fired one shot behind Versace's ear, execution-style. He fired a second shot into the fashion mogul's cheek, just to the right of his nose. Versace fell. Blood dripped down the rock steps, splattering over Versace's sunglasses and flip-flops, an image repeatedly broadcast and published the world over.

Versace's lover and friends heard the shots and spilled out onto the sidewalk. Cunanan calmly walked away from it all. In the chaos, one of Versace's friends gave chase but stopped when Cunanan pointed the .40 caliber Taurus in his direction. Cunanan then vanished into one of Miami Beach's alleyways.

Rescue workers arrived and tried to keep Versace alive; they didn't know his spine had been severed. For Cunanan, all was going as planned. He was going to jump into his pickup truck and drive right out of the parking garage—an easy escape. But the sound of a wailing police siren nearby made him hesitate. He paused to rethink his escape. Shaken and thinking he was about to be caught by police, Cunanan stripped off his blood-splattered T-shirt and bolted from the garage on foot.

The siren turned out to be coming from a cop car investigating a nearby car accident. Cunanan had made a mistake. The bloody shirt and truck left behind would soon help police learn his true identity and link him to Versace's murder. An eight-day manhunt was about to get underway.

Miami Beach Detective Robert Hernandez, a public information officer at the time, was nearby buying a smoothie when he heard the call and was among the first to arrive at Versace's mansion. "There was a patrol officer already there, but he had no idea who the victim was. When I saw him, I said, 'Do you know who that is? That's Versace! This is going to be big.' I called the lead PIO at the time, Al Boza, and told him, 'Get ready.'"

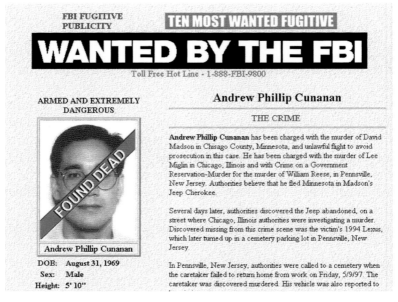

FBI FUGITIVE PUBLICITY

TEN MOST WANTED FUGITIVE

WANTED BY THE FBI

Toll Free Hot Line - 1-888-FBI-9800

ARMED AND EXTREMELY DANGEROUS

Andrew Phillip Cunanan

FOUND DEAD

Andrew Phillip Cunanan

DOB: August 31, 1969
Sex: Male
Height: 5' 10"

THE CRIME

Andrew Phillip Cunanan has been charged with the murder of David Madson in Chisago County, Minnesota, and unlawful flight to avoid prosecution in this case. He has been charged with the murder of Lee Miglin in Chicago, Illinois and with Crime on a Government Reservation-Murder for the murder of William Reese, in Pennsville, New Jersey. Authorities believe that he fled Minnesota in Madson's Jeep Cherokee.

Several days later, authorities discovered the Jeep abandoned, on a street where Chicago, Illinois authorities were investigating a murder. Discovered missing from this crime scene was the victim's 1994 Lexus, which later turned up in a cemetery parking lot in Pennsville, New Jersey.

In Pennsville, New Jersey, authorities were called to a cemetery when the caretaker failed to return home from work on Friday, 5/9/97. The caretaker was discovered murdered. His vehicle was also reported to

FBI mug shot of Andrew Cunanan after authorities found his body in a Miami Beach houseboat. He killed himself before police could arrest him for the murder of fashion designer Gianni Versace and four other victims. *Courtesy of the* Miami Herald.

Indeed, reporters from newspapers, radio, television and the Internet quickly got wind of what appeared to be a sensational story, one of the world's most famous fashion designers slain in broad daylight in front of his Miami Beach home. Within hours, the news got even juicier. Versace's killer was identified as Cunanan, a spree killer who only weeks before had been listed on the FBI's "Ten Most Wanted" list.

They had learned his identity from the pickup truck left behind in the garage. Cunanan had apparently been living out of the vehicle. Police found more than two hundred items, including socks, T-shirts, Gap boxer shorts and a bar of soap in the cup holder. In one suitcase, they discovered a tourist map of Key West, as well as gay and lesbian guides to Fort Lauderdale, New Orleans, Manhattan, New Jersey, Philadelphia and the United States.

"It went from a whodunit to a he-done-it, but now, not only did we have a dead world-famous designer, he had been killed by a serial killer who was on the loose," said then City Manager José Garcia-Pedrosa, sixty-one years old and now president and CEO of the National Parkinson Foundation in Miami. "The story had everything: violence, sex, suspense…And there was a mystery, too. Why did Cunanan kill Versace?" That question would never be answered.

The relentless international media spotlight plunged Miami Beach into a live twenty-four-hour circus show. Reporters from across the country and globe rushed into town. CNN offered hourly updates. Satellite trucks populated Miami Beach. It wasn't a pretty image for a city that only a decade earlier had shed its shoddy hotels and replaced them with a sizzling avenue of chic. South Beach had become the place to be and the place to be seen. Local residents were none too thrilled either as a sense of panic gripped much of South Florida. Miami Beach was turned upside down.

Catching Cunanan became an obsession for the FBI, Miami Beach and Miami-Dade Police and the Florida Department of Law Enforcement. The mayor at the time, Seymour Gelber, who still lives in the area, stated, "The furor created by the Versace murder is something that had never happened on Miami Beach before—and I've lived here since 1946."

The job of solving the Versace murder and finding Cunanan fell to several veteran Miami Beach detectives, including Paul Scrimshaw and Gary Schiaffo. They began chasing lead after lead—most dead ends. "There were more sightings of Cunanan than Elvis," said the Bronx-born Schiaffo, who resembles actor Dennis Farina. "Everybody was seeing the guy, and we had to chase down every tip."

One bizarre theory was that Versace was killed by the mafia. Next to Versace's body was a dead pigeon—a mob calling card. Turns out the pigeon was the victim of a freak accident, killed by a bullet that exited Versace's skull and ricocheted off his ornate iron gate—hitting the bird in the eye.

The theories and tips seemed endless, and fruitless. Finally, a break came on July 23. That afternoon, Schiaffo heard a call

on the police radio that caught his attention: "Shots fired in a houseboat on 52nd Street and Indian Creek." Could it be Cunanan? Schiaffo had a feeling it was. "Days earlier, a guy who owned a yacht just three blocks away from the houseboat had reported that someone he thought was Cunanan had ransacked his yacht," Schiaffo recalled. "I jumped in my car and headed that way."

Schiaffo was the first detective at the houseboat for what would become a twelve-hour siege. Schiaffo learned that a caretaker, Fernando Carreira, had come to the houseboat to check on it when he discovered the locks had been opened. He pushed his way in and saw that someone had been living there. Then he bolted when a shot rang out. Police decided to tear-gas the houseboat, but getting the smoke out took hours. Meanwhile, the media was kept at bay and in the dark about the suspect's actual identity. The police would remain mum for hours.

Schiaffo and a crime lab technician finally entered and found Cunanan dead, lying on a bed upstairs, just forty-one blocks from the Versace mansion. He had shot himself in the mouth with the same gun—a .40 caliber pistol—that he had used on Versace and his other victims. He was wearing a pair of gray boxer shorts. His hair was cropped close and a beard covered his face. He was hardly a kid from California anymore.

Although friends had told authorities that Cunanan was a drug user, an autopsy showed no drugs or alcohol in his system. It also debunked an earlier theory that Cunanan killed because he was angry at being HIV positive. He, in fact, did not have the AIDS virus. Cunanan was, however, nursing a small, mysterious stomach wound, which explains why police found an unlabeled prescription medicine bottle in the houseboat that contained nineteen penicillin capsules, bloody gauze pads, cotton swabs and bandages. He was apparently nursing himself. Police never determined the origin of the wound.

The houseboat's owner, Thorsten Reineck, a fifty-two-year-old German national, had been gone for months. He owned a gay bathhouse in Las Vegas, but insisted he had not known Cunanan.

The houseboat where Andrew Cunanan was found on July 23, 1997. It eventually sank into Indian Creek on Miami Beach. On the pier is Fernando Carreira (right), the houseboat caretaker who stumbled upon Cunanan and called police. *Courtesy of the* Miami Herald.

Wanted in his own country, he was later sent home and jailed for tax evasion in Germany.

Schiaffo believes Cunanan killed himself because he thought the caretaker was the police. "I think he thought 'this is it. I'll take care of myself or they're gonna riddle my body.' The FBI profile said he was very vain and would have preferred to kill himself," Schiaffo said.

In the days after Cunanan's houseboat suicide, the media pummeled Miami Beach Police and other law enforcement agencies for missteps. One missed opportunity, the media later learned, was that a clerk at a Miami Subs in Miami Beach— only three days before Versace's murder—thought he had seen Cunanan and reported it to police. The clerk, who had watched the television program *America's Most Wanted*, called 911. But police arrived at the sub shop too late.

In a transcript made public of the 911 call, the clerk believes Cunanan is inside the shop.

Caller: I could be wrong, you know what I'm saying? I'm not a hundred percent sure.
Operator: Which way did he go?
Caller: He's inside the store now.
Operator: He's inside the store?
Caller: Yeah.
Operator: Eating?
Caller: No, he's waiting for his food.
Operator: And he's wanted for what?
Caller: There was this, um, guy, who is, um, who killed his homosexual lover and a couple other people—like four people...you know, I'm not, I'm not a hundred percent sure but he looks like him, you know what I mean? He really looks like him. I'm not a hundred percent sure.

Later, the media discovered that the pawnshop employee Oliva, as required by law, had sent Miami Beach Police the paperwork of the transaction with Cunanan days before he killed Versace. He told her the hotel where he was staying and showed her his passport, with his real name. But the form, rich in leads to finding Cunanan, sat on a desk at police headquarters. All the information Cunanan had written down was correct, except his room number. By the time someone noticed it, Versace was dead. The embarrassment prompted Miami Beach Police to upgrade to a computerized pawnshop detail system to track such information.

Today, Schiaffo is retired from the force and works as an insurance fraud investigator for the state. His partner, Scrimshaw, saw his career and his relationship with the department go sour. Scrimshaw retired five months after the murder. He died of cancer in 2006 at sixty years old. His widow, Lynn Scrimshaw, says the case proved a curse for her husband. "It cost my husband his whole life," she said. "He lost a job that he loved and did very well. The case changed him."

Oliva, now fifty-five years old, no longer works at the pawnshop. She still can't believe she came face to face with Cunanan. "He was

as sweet as a piece of cake," she said. "I wouldn't have guessed in a million years that the man who walked in that day was a killer."

Carreira, the man who stumbled upon Cunanan in the houseboat, collected a $10,000 reward and appeared on television for weeks afterward.

A decade after Versace's death, Italian officials in the city of Milán and the Versace family were still struggling to understand why anyone would have wanted to kill the famous fashion designer. Versace's sister, Donatella, who continues to run the fashion house, issued a statement to the media describing the tenth anniversary of her brother's death as "an emotionally difficult time."

As for Versace's Italian villa at Eleventh and Ocean Drive, it is now an exclusive, high-priced hotel.

But the steps leading to it continue to be a macabre mecca for tourists.

About Sergio Bustos

Sergio Bustos is an assistant city editor with the *Miami Herald*. He joined the newspaper in May 2005 as an editor in charge of its cops and courts team.

Before joining the *Herald*, he worked as a Washington correspondent covering immigration for the Gannett-owned *Arizona Republic*.

Born in Chile and raised in the Virginia suburbs outside Washington, D.C., Bustos graduated from Virginia Commonwealth University in 1984. He went on to work at the Staunton, Virginia *Daily News Leader* and the Wilmington, Delaware *News Journal* before joining the *Philadelphia Inquirer* in 1987.

He spent nearly eight years at the *Inquirer*, where he won a Robert F. Kennedy Journalism Award in 1992 for a series of stories on how cops and courts routinely violated the rights of thousands of farm workers. Also in 1992, he was awarded a

year-long fellowship in international reporting at the University of Southern California, and he's taught journalism courses at Florida International University as well. Bustos was part of a team of reporters named as Pulitzer Prize finalists in 1995 for stories uncovering electoral fraud in a controversial state senate race.

He and his wife have two children and live in South Florida.

About Luisa Yanez

Luisa Yanez has been a reporter with the *Miami Herald* since 2000. She has also worked at the *Miami News* and the South Florida *Sun-Sentinel*.

During her years as a reporter in South Florida she has covered over five hundred homicides, including the murder of fashion designer Gianni Versace and spree killer Christopher Wilder.

She has been honored for her work by other journalists, and she won the prestigious National Headliner award, a Robert F. Kennedy award and honors from the Society of Professional Journalists.

She was born in Cuba, raised in Miami and lives in southwest Miami-Dade.

A History of Smuggling in Florida
Rumrunners and Cocaine Cowboys

Stan Zimmerman

978-1-59629-199-7 • 128 pp. • $19.99

With its long coastline, hundreds of remote landing strips and
airports clogged with sun-seeking tourists, Florida is a superhighway
of smuggling. The Sunshine State has a centuries-old history of
smuggling, and the shocking variety of contraband—from guns
and cocaine to orchids and jaguar teeth—is rivaled only by the
long list of perpetrators.

Visit us at

www.historypress.net